Introduction to

Imaging
Revised Edition

Howard Besser

Edited by Sally Hubbard with Deborah Lenert

Getty Research Institute

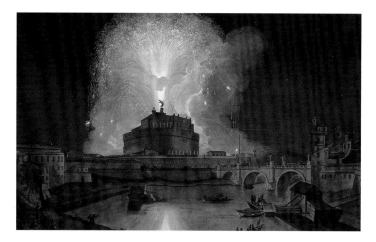

Cover image created from *Il Prospetto del Castel' S'Angiolo con lo sparo della Girandola* (detail), ca. 1780–85. Francesco Panini (Italian, 1745–1812). Etching with watercolor and gouache, 58.3 × 88.4 cm (22^{15}/$_{16}$ × 34^{13}/$_{16}$ in.). Research Library, The Getty Research Institute, 970025

The Getty Research Institute Publications Program
Thomas Crow, *Director, Getty Research Institute*
Gail Feigenbaum, *Associate Director, Programs*
Julia Bloomfield, *Head, Publications Program*

Introduction to Imaging
Revised Edition
Patrick Pardo, *Manuscript Editor*
Elizabeth Zozom, *Production Coordinator*
Designed by Hespenheide Design, Westlake Village, California
Printed and bound in Canada by Transcontinental, Litho Acme, Montreal
Color separations by Professional Graphics Inc., Rockford, Illinois

Published by the Getty Research Institute, Los Angeles
Getty Publications
1200 Getty Center Drive, Suite 500
Los Angeles, CA 90049-1682
www.getty.edu

Library of Congress Cataloging-in-Publication Data
Besser, Howard.
Introduction to imaging / Howard Besser ; edited by
 Sally Hubbard with Deborah Lenert.– Rev. ed.
 p. cm.
Includes bibliographical references.
 ISBN 0-89236-733-4
 1. Image processing–Digital techniques. I. Hubbard, Sally.
II. Lenert, Deborah. III. Title.
TA1637.B477 2003
006.6–dc21

 2003008823

Acknowledgments
The author and editors gratefully acknowledge Roger Howard, Steven Swimmer, Grace Agnew, and Linda Tadic for their review of the manuscript of the revised edition, and Jean-François Blanchette and Tony Gill for their comments on specific sections. We would also like to thank Jennifer Trant, coauthor of the first edition, and David Bearman, Steve Dietz, Christine Sundt, and Marilyn Schmitt for their review of the manuscript of the first edition.

Reader's Note
Words that appear in **boldface** are defined in the glossary, which gives brief definitions of the most commonly used terms in this field.

Contents

Introduction

Few technologies have offered as much potential to change research and teaching in the arts and humanities as **digital** imaging. The possibility of examining rare and unique objects outside the secure, climate-controlled environments of museums and archives liberates collections for study and enjoyment. The ability to display and link collections from around the world breaks down physical barriers to access, and the potential of reaching audiences across social and economic boundaries blurs the distinction between the privileged few and the general public. Like any technology, however, digital imaging is a tool that should be used judiciously and with forethought.

In the earliest stages of the digital era, most digital imaging projects were ad hoc, experimental in nature, and relatively small in scope. The result was a series of idiosyncratic and disconnected projects that died with their creators' tenure or with their storage media, demonstrating that one of the requirements for the establishment of useful, sustainable, and **scalable** digital image collections—collections that are **interoperable** with broader information systems—was the development and implementation of data and technology **standards.**

The line that formerly divided everyday **analog** or traditional activities and specialized digital projects has eroded, and the creation of digital image collections is now an integral and expected part of the workflow of museums and other cultural heritage organizations. Unfortunately, the world of imaging has not necessarily become easier to navigate on that account. A plethora of differing image **format** and **documentation** or **metadata** standards has emerged, and a wide variety of hardware and software designed to create, manage, and store such collections has become available. Not only must collection managers choose between the different hardware, software, and metadata options, but because digital entities differ in fundamental ways from their analog counterparts, the management of hybrid collections (which encompass both digital and analog objects) also requires the development of new and different skill sets and even staff

positions. It may also prompt the reappraisal of work processes and protocols within an institution.

In short, the establishment and maintenance of digital image collections are complicated and challenging undertakings that require a long-term commitment. There is no single best practice, best software, or best system for the task, but there are some basic premises and guidelines that can help institutions make the decisions that best fit their own priorities, environment, and budget.

Introduction to Imaging is designed to help curators, librarians, collection managers, administrators, scholars, and students better understand the basic technology and processes involved in building a deep and cohesive set of digital images and linking those images to the information required to access, preserve, and manage them. It identifies the major issues that arise in the process of creating an image collection and outlines some of the options available and choices that must be made. Areas of particular concern include **integration** and interoperability with other information resources and activities; the development of a strategy that does not limit or foreclose future options and that offers a likely upgrade path; and ensuring the longevity of **digital assets.**

Our discussion begins with a brief review of some key concepts and terms basic to an understanding of digital imaging. A **digital image** is understood here as a **raster** or **bitmapped** representation of an analog work of art or artifact. **Vector graphics**, geometrical objects such as those created by drawing software or **CAD** (computer-aided design) systems, and other works that are "**born digital**" are not specifically dealt with here, nor are images made with different light-wave lengths, such as X-radiographs. However, much of the information on the importance of metadata, standards, and **preservation** is relevant to all digital files of whatever type and provenance.

For those planning a digital image collection, this overview is merely a beginning. Other resources are outlined, and additional sources of information are included in the bibliography. Acronyms and jargon abound in the digital imaging and the digital library universes. Every effort has been made here to avoid these when possible and to explain them where they are unavoidable.

Howard Besser and Sally Hubbard

Part I Key Concepts and Terms

The Digital Image Defined

A bitmapped digital image is composed of a set of dots or squares, called **pixels** (from *pic*ture *el*ements), arranged in a matrix of columns and rows. Each pixel has a specific color or shade of gray, and in combination with neighboring pixels it creates the illusion of a **continuous tone** image. This matrix is created during the scanning process, in which an analog original is **sampled** at regular intervals, or the color of selected points of its surface, corresponding to each pixel, is recorded. Generally speaking, the more **samples** taken from the source image, the more accurate the resulting digital surrogate will be. Digital image files are commonly divided into "master" and "derivative" versions. **Master files** are the highest quality files available, usually the originals created by the sampling process. It is from these that further copies of the images are derived, and often manipulated, to create lower-quality and more easily distributed **access files**.

Digital files do not have any independent material existence; rather, they exist as data or binary code until they are rendered by intermediary technology: application software running on a given operating system running on a particular hardware platform. One effect of this is that digital image files are particularly vulnerable to format obsolescence and media decay, and, therefore, ensuring the longevity of digital images can be complicated and costly. Another effect is that a single digital image may manifest itself differently in different circumstances according to a number of variables. Finally, digital images cannot be directly located or searched; this must be done indirectly through the information that describes them—their metadata—created either manually or with automatic **indexing** software. A digital image not associated with metadata will be difficult to find or identify and is likely to become useless very quickly. In fact, in order for data (in this case, the content or "essence" of a digital image file) to have continuing value and to be worth preserving, both it and its related metadata should be managed as a single entity, sometimes known as a **digital object** or a digital asset.

Standards

National and international standards exist to ensure that data will be inter-changeable between systems and institutions and sustainable in the long term, and that systems and applications will themselves be interoperable. They are the tools that make accessible, sustainable, and interoperable dig-ital image collections feasible. Adherence to data standards (for instance, by stating than an image is a reproduction of *The Last Supper* by Leonardo da Vinci in a predictable and recognized way) allows precise search and retrieval and may also save **cataloguing** and indexing time by making it possible to incorporate portions of documentation records from other institutions or previous projects into new records. The transitory nature of digital technology demands that technical standards be applied to the creation and documentation of digital image files if they are not swiftly to become defunct.

There are many data, descriptive, indexing, and technical stan-dards available, developed by various institutions and communities. The difficulty usually lies in the selection of the most appropriate combination of standards and their customization, if necessary, to suit the particular needs of the institution and project. If possible, choose **open standards** rather than **proprietary** ones, as the latter may be idiosyncratic and/or reliant upon knowledge or equipment that may not always be freely and generally available, and thus lead to a sacrifice of interoperability and longevity. The National Digital Library Program of the Library of Congress, the California Digital Library, and the Colorado Digitization Program are some examples of groups that have made available their own standards, guidelines, and best practice recommendations for all aspects of imaging projects, and these can be immensely helpful (see *Online Resources*). When considering adopting a standard, it is important to consider how well established vendors support it and the depth of its user base. For instance, individual manufacturers and developers may support different subsets of the total specifications for a technical standard or modify specifications to the extent that the standard is broken. This can lead to decreased interop-

erability. Research—or consultation with an experienced imaging specialist—can help sort out how well a standard is supported and by whom.

Technical standards addressing a broad range of information technology issues, including file formats and technical **metadata schemas,** are maintained and developed by international organizations. Examples include the International Organization for Standardization (**ISO**); the International Electrotechnical Commission (**IEC**); the Institute of Electrical and Electronics Engineers (**IEEE**); the International Telecommunications Union (**ITU**); and the World Wide Web Consortium (**W3C**), which develops vendor-neutral open standards and specifications for **Internet** and **Web**-based transactions, with the intent of promoting interoperability. National standards bodies—including the American National Standards Institute (**ANSI**), the U.S. National Information Standards Organization (**NISO**), the British Standards Institution (**BSI**), and the German Deutsches Institut für Normung (**DIN**)—not only define and endorse their own standards but also support the work of international agencies. The NISO *Data Dictionary: Technical Metadata for Digital Still Images* (released as a draft standard in 2002) is particularly worthy of note, because it was developed for cultural institutions (and other organizations) interested in maintaining collections of digital still images. (See *Selecting a Metadata Schema*). Technical standards may also be developed within an industry or an individual company. These may or may not be subjected to a formal standards-making process and are often proprietary.

Note that standards evolve and new standards emerge. Ensuring that imaging processes conform to current standards will involve vigilance and a continual investment in updating and **migrating** information.

Metadata

Commonly defined as "data about data," metadata constitutes the documentation of all aspects of digital files essential to their persistence and usefulness and should be inextricably linked to each digital image. Metadata is captured in the form of a prescribed list of elements, or fields, known as a metadata schema. Each schema is tailored to a specific domain or purpose (see *Selecting a Metadata Schema*). Metadata schemas should be distinguished from metadata format: information in any given metadata schema can be formatted in a number of different ways—as a physical card-catalogue entry, a set of fields for a **database** or collection management system record, or an **XML** (Extensible Markup Language) document—and still convey the same meaning. The advantage of the increasingly popular XML format is that it provides a mechanism for encoding semantic data, as defined by a metadata schema, that facilitates data sharing and automated data processing. (For a more detailed discussion of the XML format, see *Metadata Format.*) However, the quality and consistency of metadata are more important than the particular format in which it is expressed or the software used to generate it: bad metadata in a sophisticated **native-XML** database will be less valuable than good metadata in a simple desktop spreadsheet, which can likely be migrated to new formats if need be. "Good" metadata was defined in 2001 by the Digital Library Forum as fulfilling the following criteria: it is appropriate to the materials digitized and their current and likely use; it supports interoperability; it uses standard **controlled vocabularies** to populate elements where appropriate; it includes a clear statement on the terms of use of the digital object; it supports the long-term management of digital objects; and it is persistent, authoritative, and verifiable.[1]

The depth and complexity of metadata captured will vary from one project to another depending on local policies and user needs, but images without appropriate metadata will quickly become useless—impossible to find, view, or migrate to new technology as this inevitably becomes neces-

sary. It is metadata that allows collection managers to track, preserve, and make accessible digital images and enables end users to find and distinguish between various images. Metadata also allows digital image collections to be reused, built upon, and become part of larger cultural heritage offerings within and across institutions.

Metadata can be divided into three broad types, which may be simply defined as follows: descriptive, which describes content; administrative, which describes context and form and gives data-management information; and structural, which describes the relationships between parts and between digital files or objects.[2] The first is most akin to traditional cataloguing and would describe what a digital image depicts or its essence. This is essential for end-user access and to allow efficient search and retrieval. Administrative metadata records information such as how and why a digital object was created, and is used in the management of digital objects. Structural metadata documents information such as the fact that one image is a detail of the upper-right corner of another image, that a particular image depicts page two of a book of thirty-four pages, or that an image is one item in a given series.

Metadata may also be divided into more specific categories: for instance, rights metadata is used in **rights management** and documents with whom the intellectual property (**IP**) rights of a particular image or collection reside and describes access and usage restrictions. It may specify at what quality an image may be reproduced or the credit line that is required to accompany its display. Technical metadata documents aspects of files or collections that are distinct from their intellectual content or essence, such as production, format, and processing information. Preservation metadata documents the information necessary to ensure the longevity of digital objects. There is obvious crossover among these categories; preservation metadata is primarily a combination of administrative and structural metadata elements, or alternatively is primarily a subset of technical metadata.

It is important in this context to mention **CBIR**, or content-based information retrieval. CBIR technology is able to retrieve images on the basis of machine-recognizable visual criteria. Such indexing is able to recognize and retrieve images by criteria such as color, iconic shape, or by the position of elements within the image frame. Stock-photo houses that cater to the advertising industry have had some success in using this automatic indexing to answer such queries as "find images with shades of blue in the top part of the frame and shades of green in the bottom part" (i.e., landscapes). As this technology becomes more sophisticated, it is likely that automatic and manual indexing will be used together to describe and retrieve images.

Metadata Crosswalks and Controlled Vocabularies

To make different metadata schemas work together and permit broad
cross-domain resource discovery, it is necessary to be able to map equiva-
lent or nearly equivalent elements from different schemas to each other,
something that is achieved by metadata **crosswalks**. The Getty Research
Institute and the Library of Congress offer crosswalks between various
metadata schemas, and UKOLN (UK Office for Library and Information
Networking) maintains a Web page linking to a variety of crosswalk and
metadata mapping resources. When integrated into search software, such
crosswalks allow the retrieval of diverse records contained in different
repositories and aid the migration of data to new systems. (See *Metadata
Format* for a discussion of the use of **RDF**—Resource Description
Framework—in Web crosswalks.)

Crosswalks are only a part of a coherent data structuring. Con-
trolled vocabularies, **thesauri**, **authorities**, and **indices** provide accurate
and consistent content with which to populate metadata elements. Their
use improves searching precision and recall and enables automated inter-
operability. For example, a streamlined arrangement of the totality of data
describing an image file might include a distinction between intrinsic and
extrinsic information, the latter being ancillary information about persons,
places, and concepts. Such information might be important for the de-
scription and retrieval of a particular work but is more efficiently recorded
in separate "authority" records than in records about the work itself. In
this type of system, such information is captured once (authoritatively)
and may be linked to all appropriate work records as needed, thus avoid-
ing redundancy and the possible introduction of error.

Examples of controlled vocabularies include the *Library of
Congress Subject Headings* (**LCSH**), *Name Authority File* (**NAF**), and
Thesaurus for Graphic Materials I and II (**TGM-I** and **TGM-II**); the *Art
& Architecture Thesaurus* (**AAT**), the *Getty Thesaurus of Geographic Names*
(**TGN**), and the *Union List of Artist Names* (**ULAN**), all maintained by
the Getty Research Institute; and **ICONCLASS**, a subject-specific inter-
national classification system for iconographic research and the docu-
mentation of images. These and other vocabularies and classification
systems—many disciplines and professions have developed their own
thesauri, tailored to their particular concerns—provide a wide range of
controlled terminology to describe the people, places, things, events,
and themes depicted in images, as well as the original objects themselves.

The Image

Image Reproduction and Color Management

The human eye can distinguish millions of different colors, all of which arise from two types of light mixtures: additive or subtractive. The former involves adding together different parts of the light spectrum, while the latter involves the subtraction or absorption of parts of the spectrum, allowing the transmission or reflection of the remaining portions. Computer monitors exploit an additive system, while print color creation is subtractive. This fundamental difference can complicate both accurate reproduction on a computer monitor of the colors of an original work and accurate printing of a digital image.

On a typical video monitor, as of this writing, color is formed by the emission of light from pixels, each of which is subdivided into three discrete **subpixels**, which are in turn responsible for emitting one of the three primary colors: red, green, or blue. Color creation occurs when beams of light from each color **channel** are combined; by varying the voltage applied to each subpixel individually, thus controlling the intensity of light emitted, a full range of colors can be reproduced, from black (all subpixels off) to white (all subpixels emitting at full power). This is known as the **RGB color model** (fig. 1).

In print, however, color is created by the reflection or transmission of light from a substrate (such as paper) and layers of colored dyes or pigments, called inks, formulated in the three primary subtractive colors—cyan, magenta, and yellow (CMY). Black ink (K) may be additionally used to aid in the reproduction of darker tones, including black. This system is known as the **CMYK** color model. Printed images are not usually composed of rigid matrices of pixels but instead are created by overprinting some or all of these four colors in

Fig. 1. RGB color is a mix of red, green, and blue. Gray scale is a percentage of black.

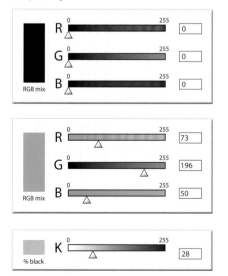

patterns that simulate varying color intensities by altering the size of the dots that are printed, in contrast with the substrate, through a process called halftoning. (There are digital printers that combine colors from the CMYK and RGB color models or add gray ink in order to make up for deficiencies in printer inks in representing a wide range of colors.)

Admittedly, this is a highly simplified overview of color. There are many different color models and variations thereof—**HSB/HLS**, which describes colors according to hue, saturation, and brightness/lightness; and **gray scale** (fig. 1), which mixes black and white to produce various shades of gray, are two common systems—and the various devices that an image encounters over its life cycle may use different ones. Variation among different display or rendering devices, such as monitors, projectors, and printers, is a particularly serious issue: a particular shade of red on one monitor will not necessarily look the same on another, for example. Brightness and contrast may also vary. The International Color Consortium (**ICC**) has defined a standardized method of describing the unique characteristics of display, output, and working environments—the ICC Profile Format—to facilitate the exchange of color data between devices and mediums and ensure color fidelity and consistency, or **color management**. An ICC **color profile** acts as a translator between the **color space** of individual devices and a device-independent color space (**CIE LAB**) that is capable of defining colors absolutely. This allows all devices in an image-processing workflow to be **calibrated** to a common standard that is then used to map colors from one device to another. Color management systems (**CMS**), which are designed for this purpose, should be selected on the basis of their support for the ICC Profile Format rather than competing proprietary systems.

ICC profiling ensures that a color is correctly mapped from the input to the output color space by attaching a profile for the input color space to the digital image. However, it is not always possible or desirable to do this. For instance, some file formats do not allow color profiles to be embedded. If no instructions in the form of tags or embedded profiles in the images themselves are available to a user's **Web browser**, the browser will display images using a default color profile. This can result in variation in the appearance of images based on the operating system and color space configuration of the particular monitor. In an attempt to address this problem, and the related problem of there being many different RGB color spaces, Hewlett-Packard and Microsoft jointly developed **sRGB**, a calibrated, standard RGB color space wherein RGB values are redefined in terms of a device-independent color specification that can be embedded during the creation or derivation of certain image files. Monitors can be configured to use sRGB as their default color space, and sRGB has been proposed as a default color space for images delivered over the **World Wide Web**. A mixed sRGB/ICC environment would use an ICC profile

if offered, but in the absence of such a profile or any other color information, such as an alternative platform or application default space, sRGB would be assumed. Such a standard could dramatically improve color consistency in the desktop environment.

Bit Depth/Dynamic Range

The **dynamic range** of an image is determined by the potential range of color and luminosity values that each pixel can represent in an image, which in turn determines the maximum possible range of colors that can be represented within an image's color space or **palette**. This may also be referred to as the **bit depth** or **sample depth**, because digital color values are internally represented by a binary value, each component of which is called a **bit** (from *bi*nary digi*t*). The number of bits used to represent each pixel, or the number of bits used to record the value of each sample, determines how many colors can appear in a digital image.

Dynamic range is sometimes more narrowly understood as the ratio between the brightest and darkest parts of an image or scene. For instance, a scene that ranges from bright sunlight to deep shadows is said to have a high dynamic range, while an indoor scene with less contrast has a low dynamic range. The dynamic range of a capture or display device dictates its ability to describe the details in both the very dark and very light sections of the scene.

Early monochrome screens used a single bit per pixel to represent color. Since a bit has two possible values, 1 or 0, each pixel could be in one of two states, equivalent to being on or off. If the pixel was "on," it would glow, usually green or amber, and show up against the screen's background. The next development was 4-bit color, which allows 16 possible colors per pixel (because 2 to the 4th power equals 16). Next came 8-bit color, or 2 to the 8th power, allowing 256 colors (compare figs. 2 and 3). These color ranges allow simple graphics to be rendered—most icons, for example, use either 16 or 256 colors—but are generally inadequate for representing photographic-quality images.

The limitations of 256-color palettes prompted some users to develop **adaptive palettes**. Rather than accepting the generic system palette, which specified 256 fixed colors from across the whole range of possible colors, optimal sets of 256 colors particularly suited or adapted to the rendering of a given image were chosen. So, for example, instead of a fixed palette of 256 colors divided roughly equally across the color spectrum (leaving perhaps eight shades of green), the 256 colors might be primarily devoted to greens and blues in an image of a park during summer, or to shades of yellow and gold for an image depicting a beach on a sunny day. While they may

Fig. 2. The full color spectrum

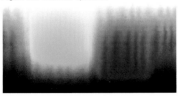

Fig. 3. The spectrum in 256 colors

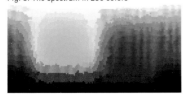

enhance the fidelity of any given digital image, adaptive palettes can cause problems. For instance, when multiple images using different palettes are displayed at one time on a system that can only display 256 colors, the system is forced to choose a single palette and apply it to all the images. The so-called **browser-safe palette** was developed to make color predictable on these now largely obsolete 256-color systems. This palette contains the 216 colors whose appearance is predictable in all browsers and on Macintosh machines and IBM-compatible or **Wintel** personal computers (the remaining 40 of the 256 colors are rendered differently by the two systems), so the browser-safe selection is optimized for **cross-platform** performance. While this palette is still useful for Web page design, it is too limited to be of much relevance when it comes to high-quality photographic reproduction.

Sixteen-bit color offers 65,000 color combinations. In the past this was sometimes called "high color," or "thousands of colors" on Macintosh systems, and is still used for certain graphics. Twenty-four-bit color allows every pixel within an image to be represented by three 8-bit values ($3 \times 8 = 24$), one for each of the three primary color components (channels) in the image: red, green, and blue. Eight bits (which equal one **byte**) per primary color can describe 256 shades of that color. Because a pixel consists of three primary color channels, this allows the description of approximately 16 million colors ($256 \times 256 \times 256 = 16,777,216$). This gamut of colors is commonly referred to as "**true color**," or "millions of colors" on Macintosh systems.

As of this writing, 24-bit color display is the highest bit depth obtainable by affordable monitors; although many monitors now offer what is called 32-bit display, this is actually 24 bits of color data and 8 bits of "alpha" or transparency data. It is in fact debatable whether many monitors can even display the full range of 24-bit color, but most do accept 24-bit video signals from their system's **video card**, the circuit board that enables a computer to display information. Experimental monitors that can display 30-bit color (10 bits per color channel) have been demonstrated, and it is possible that such monitors will become more generally available in the future. (The ability of most printers to accurately represent higher bit depths is also limited.)

Given the limitations of computer monitor display, the advantages of capturing any image at greater than 24-bit color may not be obvious, but many institutions are moving toward 48-bit-color **image capture** for archival purposes. This extends the total number of expressible colors by a factor of roughly 16 million, resulting in a color model capable of describing 280 trillion colors. Such "high-bit" or high dynamic range imaging (**HDRI**)—that is, imaging that exploits bit depths of 48, 96, or even higher—actually uses the "extra" bits less to capture ever more

colors than to render differences in light and shade (luminance) more accurately. The primary purpose of doing so is to preserve as much original data as possible: since many **scanners** and **digital cameras** capture more than 24 bits of color per pixel, using a color model that can retain the additional precision makes sense for image archivists who wish to preserve the greatest possible level of detail. Additionally, using a high-bit color space presents imaging staff with a smoother palette to work with, resulting in less color banding and cleaner editing and **color correction**.

The following set of images shows the effect of differing levels of sample depth both on the appearance of a digital image and on the full size of the image file. The examples, all of which were captured from a 4-by-5-inch photographic transparency at a resolution of 300 samples per inch (see Resolution), *are shown magnified, for comparison.*

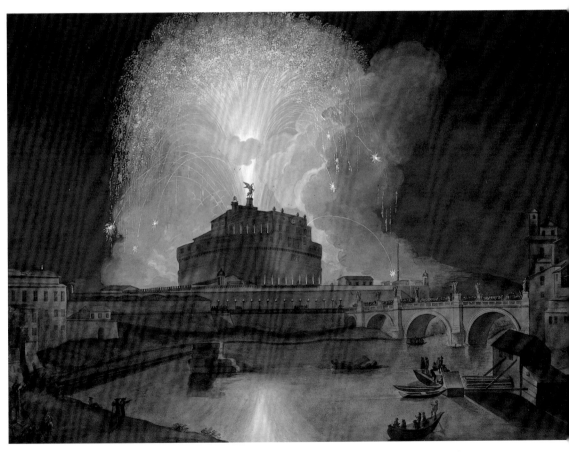

Fig. 4 (above and following page). Francesco Panini (Italian, 1745–1812), *Il Prospetto del Castel' S'Angiolo con lo sparo della Girandola,* ca. 1780–85. Etching with watercolor and gouache, 58.3 × 88.4 cm (22¹⁵/₁₆ × 34¹³/₁₆ in.). Research Library, The Getty Research Institute, 970025

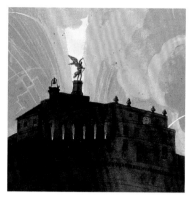

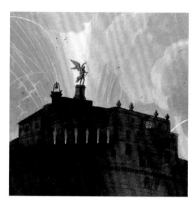

4-bit (16 colors), 2.55 megabytes (RGB)

8-bit (256 colors), 5.1 megabytes (RGB)

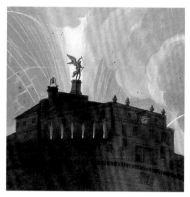

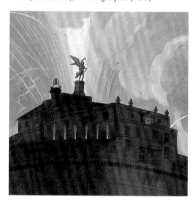

24-bit (16 million colors), 15.3 megabytes (RGB)

48-bit (280 trillion colors), 30.6 megabytes (RGB)

In each example, take note of the high-contrast areas and the color of the clockface.
Higher-bit images show greater detail and color range.

Resolution

Resolution—usually expressed as the density of elements, such as pixels, within a specific area—is a term that many find confusing. This is partly because the term can refer to several different things: **screen resolution, monitor resolution, printer resolution, capture resolution, optical resolution, interpolated resolution, output resolution,** and so on. The confusion is exacerbated by the general adoption of the dpi (dots per inch) unit (which originated as a printing term) as a catchall measurement for all forms of resolution. The most important point regarding resolution is that it is a relative rather than an absolute value, and therefore it is meaningless unless its context is defined. Raster or bitmapped images are made up of a fixed grid of pixels; unlike scalable vector images, they are resolution-dependent, which means the scale at which they are shown will affect their appearance. (For example, an image that appears to contain smoothly grad-

uated colors and lines when displayed at 100% will appear to be made up of discontinuous, jagged blocks of color when displayed at 200%.)

Screen resolution refers to the number of pixels shown on the entire screen of a computer monitor and may be more precisely described in pixels per inch (ppi) than dots per inch. The number of pixels displayed per inch of a screen depends on the combination of the monitor size (15 inch, 17 inch, 20 inch, etc.) and display resolution setting (800 × 600 pixels, 1024 × 768 pixels, etc.). Monitor size figures usually refer to the diagonal measurement of the screen, although its actual usable area will typically be less. An 800-by-600-pixel screen will display 800 pixels on each of 600 lines, or 480,000 pixels in total, while a screen set to 1024 × 768 will display 1,024 pixels on each of 768 lines, or 786,432 pixels in total, and these pixels will be spread across whatever size of monitor is employed. An image displayed at full size on a high-resolution screen will look smaller than the same image displayed at full size on a lower-resolution screen.

It is often stated that screen resolution is 72 dpi (ppi) for Macintosh systems, or 96 dpi (ppi) for Windows systems: this is not in fact the case. These figures more properly refer to monitor resolution, though the two terms are often used interchangeably. Monitor resolution refers to the maximum possible resolution of given monitors. Higher monitor resolution indicates that a monitor is capable of displaying finer and sharper detail, or smaller pixels. Monitor detail capacity can also be indicated by **dot pitch**—the size of the distance between the smallest physical components (phosphor dots) of a monitor's display. This is usually given in measurements such as 0.31, 0.27, or 0.25 millimeters (or approximately 1/72nd or 1/96th of an inch) rather than as a per inch value.

Printer resolution indicates the number of dots per inch that a printer is capable of printing: a 600-dpi printer can print 600 distinct dots on a one-inch line. Capture resolution refers to the number of samples per inch (spi) that a scanner or digital camera is capable of capturing, or the number of samples per inch captured when a particular image is digitized. Note the difference between optical resolution, which describes the values of actual samples taken, and interpolated resolution, which describes the values that the capture device can add between actual samples captured, derived by inserting values between those recorded; essentially the scanner "guesses" what these values would be. Optical resolution is the true measure of the quality of a scanner. Pushing a capture device beyond its optical resolution capacity by **interpolation** generally results in the introduction of "dirty" or unreliable data and the creation of larger, more unwieldy files. Moreover, generally speaking, when interpolation is required, image-processing software can do it more effectively than can capture devices.

Effective resolution is a term that is used in various contexts to mean rather different things. Generally it refers to "real" resolution under given circumstances, though users should beware of it being used as a substitute term for interpolated resolution in advertisements for scanners. The effective resolution of a digital camera refers to the possible resolution of the photosensitive capture device, as constrained by the area actually exposed by the camera lens. The term is also used to describe the effect of scaling or **resizing** on a file. For instance, a 4-by-6-inch image may be scanned at 400 spi at a scale of 100%—but if the resultant image file is reduced to half size (in a page layout, for instance), its effective resolution will become 800 dpi, while if it is doubled in size, its effective resolution will become 200 dpi. Effective resolution may also be used when accounting for the size of the original object or image when deciding upon capture resolution, when scanning from an intermediary. For example, a 35mm (1.5-inch) negative of a 4-by-6-inch original work would have to be scanned at 2400 spi to end up with what is effectively a 600-spi scan of the original. This number is arrived at through the formula: (longest side of the original × the desired spi) ÷ longest side of the intermediary.

The density of pixels at a given output size is referred to as the output resolution: each type of output device and medium, from monitors to laser printers to billboards, makes specific resolution demands. For instance, one can have an image composed of 3600 pixels horizontally and 2400 pixels vertically, created by scanning a 4-by-6-inch image at 600 spi. However, knowing this gives no hints about the size at which this image will be displayed or printed until one knows the output device or method and the settings used. On a monitor set to 800 × 600 screen resolution, this image would need some four-and-a-half screen lengths to scroll through if viewed at full size (actual size as measured in inches would vary according to the size of the monitor), while a 300-dpi printer would render the image—without modification—as 8 by 12 inches. During digitization, the output potential for an image should be assessed so that enough samples are captured to allow the image to be useful for all relevant mediums but not so much that the cost of **storage** and handling of the image data is unnecessarily high. Many **digitizing** guidelines specify **image resolution** via horizontal and vertical axis pixel counts, rather than a per inch measurement, because these are easier to apply meaningfully in different circumstances.

As discussed in earlier sections (See *Image Reproduction and Color Management* and *Bit Depth/Dynamic Range*), output devices are currently the weakest link in the image-quality chain. While images can be scanned and stored at high dynamic range and high resolution, affordable monitors or projectors are not available at present to display the full resolution of

such high-quality images. However, improved output devices are likely to become available in the coming years.

The following set of images shows the effect of differing levels of capture resolution both on the appearance of a digital image and on the full size of the image file. The examples, all of which were captured from a 4-by-5-inch photographic transparency at a resolution of 300 spi and a bit depth of 24, are shown magnified, for comparison.

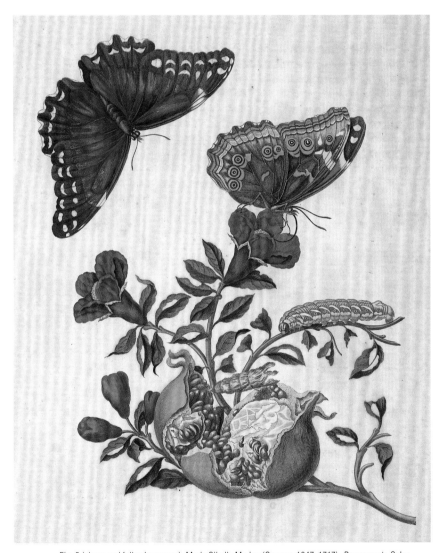

Fig. 5 (above and following pages). Maria Sibylla Merian (German, 1647–1717), *Pomegranate*. Color engraving, 53.3 × 37.8 cm (21 × 14⅞ in.), from: *Metamorphosis insectorum Surinamensium*. (Amsterdam: Joannes Oosterwyk, 1719). Research Library, The Getty Research Institute, 89-B10750

800 spi, 56 megabytes (RGB)

400 spi, 14 megabytes (RGB)

200 spi, 3 megabytes (RGB)

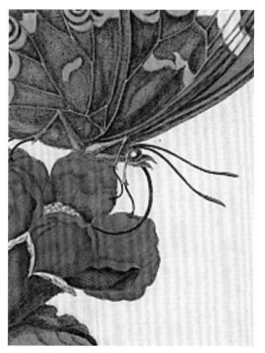

100 spi, .875 megabyte (RGB)

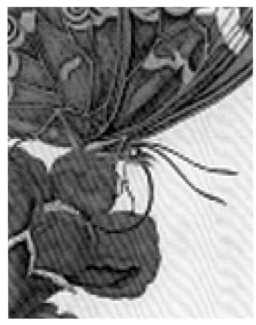

Compare the antennae in these five examples. Images captured at a higher resolution allow finer detail.

50 spi, .22 megabyte (RGB)

Compression

Image **compression** is the process of shrinking the size of digital image files by methods such as storing redundant data (e.g., pixels with identical color information) more efficiently or eliminating information that is difficult for the human eye to see. Compression **algorithms**, or **codecs** (*co*mpressors/*dec*ompressor*s*), can be evaluated on a number of points, but two factors should be considered most carefully: compression ratios and generational **integrity**. Compression ratios are simple comparisons of the capability of schemes, expressed as a ratio of compressed image size to uncompressed size; so, a ratio of 4:1 means that an image is compressed to one-fourth its original size. Generational integrity refers to the ability of a compression scheme to prevent or mitigate loss of data—and therefore image quality—through multiple cycles of compression and **decompression.** In the analog world, generational loss, such as that incurred when duplicating an audiocassette, is a fact of life, but the digital realm holds out at least the theoretical possibility of perfect duplication, with no deterioration in quality or loss of information over many generations. Any form of compression is likely to make long-term generational integrity more difficult; for this reason it is recommended that **archival master** files, for which no intentional or unavoidable degradation is acceptable, be stored uncompressed if possible.

Lossless compression ensures that the image data is retained, even through multiple compression and decompression cycles, at least in the short term. This type of compression typically yields a 40% to 60% reduction in the total data required to store an image, while not sacrificing the precision of a single pixel of data when the image is decompressed for viewing or editing. Lossless schemes are therefore highly desirable for archival digital images if the resources are not available to store uncompressed images. Common lossless schemes include **CCITT** (a standard used to compress fax documents during transmission) and **LZW** (Lempel-Ziv-Welch, named for its creators and widely used for image compression). However, even lossless compression is likely to complicate decoding the file in the long term, especially if a proprietary method is used, and it is wise to beware of vendors promising "lossless compression," which may be a rhetorical, rather than a scientific, description. The technical metadata accompanying a compressed file should always include the compression scheme and level of compression to facilitate future decompression.

Lossy compression is technically much more complex because it involves intentionally sacrificing the quality of stored images by selectively discarding pieces of data. Such compression schemes, which can be used to derive access files from uncompressed (or losslessly compressed) master files, offer a potentially massive reduction in storage and **bandwidth** requirements and have a clear and important role in allowing access to digital images. Nearly all images viewed over the Web, for instance, have been created through lossy compression, because, as of this writing, bandwidth limitations make the distribution of large uncompressed or losslessly compressed images impractical. Often, lossy compression makes little perceptible difference in image quality. Many types of images contain significant natural **noise** patterns that do not require precise reproduction. Additionally, certain regions of images that would otherwise consume enormous amounts of data to describe in their totality may contain little important detail.

Lossy compression schemes attempt to strike a balance between acceptable loss of detail and the reduction in storage and bandwidth requirements that are possible with these technologies. Most lossy schemes have variable compression, meaning that the person performing compression can choose, on a sliding scale, between image quality and compression ratios, to optimize the results for each situation. While a lossless image may result in 2:1 compression ratios on average, a lossy scheme may be able to produce excellent, but not perfect, results while delivering an 8:1 or even much greater ratio, depending on the type and level of compression chosen. This could mean reducing a 10-megabyte image to 1.25 megabytes or less, while maintaining more-than-acceptable image quality for all but the most critical needs.

Not all images respond to lossy compression in the same manner. As an image is compressed, particular kinds of visual characteristics, such as subtle tonal variations, may produce **artifacts** or unintended visual effects, though these may go largely unnoticed due to the random or continuously variable nature of photographic images. Other kinds of images, such as pages of text or line illustrations, will show the artifacts of lossy compression much more clearly, as the brain is able to separate expected details, such as straight edges and clean curves, from obvious artifacts like halos on high-contrast edges and color noise. Through testing and experience, an image manager will be able to make educated decisions about the most appropriate compression schemes for a given image or set of images and their intended users. It is important to be aware that artifacts may accumulate over generations—especially if different compression schemes are used, perhaps as one becomes obsolete and is replaced by another— such that artifacts that were imperceptible in one generation may become ruinous over many. This is why, ideally, uncompressed archival master files should be maintained, from which compressed **derivative files** can be generated for access or other purposes. This is also why it is crucial to have a metadata capture and update strategy in place to document changes made to digital image files over time.

File Formats

Once an image is scanned, the data captured is converted to a particular file format for storage. File formats abound, but many digital imaging projects have settled on the formula of **TIFF** master files, **JPEG** derivative or access files, and perhaps **GIF thumbnail** files. Image files automatically include a certain amount of technical information (technical metadata), such as pixel dimensions and bit depth. This data is stored in an area of the file (defined by the file format) called the **header**, but much of the information should also be stored externally.

TIFF, or Tagged Image File Format, has many desirable properties for preservation purposes. "Tagged" refers to the internal structure of the format, which allows for arbitrary additions, such as custom metadata fields, without affecting general compatibility. TIFF also supports several types of image data compression, allowing an organization to select the most appropriate codec for their needs, and many users of TIFF opt for a lossless compression scheme such as LZW to avoid any degradation of image quality during compression. Archival users often choose to avoid any compression at all, an option TIFF readily accommodates, to ensure that image data will be simple to decode. However, industry-promoted de facto standards, like TIFF, are often implemented inconsistently or come in a variety of forms. There are so many different implementations of TIFF that many applications can

read certain types of TIFF images but not others. If an institution chooses such an industry-promoted standard, it must select a particular version of the standard, create clear and consistent rules as to how the institution will implement the standard (i.e., create a **data dictionary** defining rules for the contents of each field), and make sure that all user applications support it. Without clear consensus on a particular standard implementation, both interoperability and information exchange may be at risk.

The JPEG (Joint Photographers Experts Group) format is generally used for online presentation because its compression is extremely efficient while still giving acceptable image quality. It was developed specifically for high-quality compression of photographic images where minor perturbations in detail are acceptable as long as overall aesthetics and important elements are maintained. However, JPEG compression is lossy, so information is irretrievable once discarded, and JPEG compression above about 25% often creates visible artifacts. The format that most people know as JPEG is in fact **JFIF** (JPEG File Interchange Format), a public domain storage format for JPEG compressed images. JFIF is a very simple format that does not allow for the storage of associated metadata, a failing that has led to the development of **SPIFF** (Still Picture Interchange File Format), which can be read by JPEG-compliant readers while providing storage for more robust metadata. GIF (Graphics Interchange Format) uses LZW lossless compression technology but is limited to a 256-color palette.

It is possible that the status of TIFF as the de facto standard format for archival digital image files will be challenged by another format in the near future that will be able to serve both master and access functions. Two possible candidates are **PNG** (Portable Network Graphics) and **JPEG2000**. PNG was designed to replace GIF. It supports 24- and 48-bit color and a lossless compression format and is an ISO/IEC standard. Application support for PNG is strong and growing. By contrast, JPEG2000 uses **wavelet compression**, which offers improved compression with greater image quality. It also allows for lossless compression and for the end user to specify resolution to accommodate various bandwidths, monitors, and browsers. The JPEG2000 standard defines two file formats, both of which support embedded XML metadata: JP2, which supports simple XML; and JPX, which has a more robust XML system based on an embedded metadata initiative of the International Imaging Industry Association: the DIG35 specification. However, as of this writing, commercial implementations for JPEG2000 are just beginning to appear.

The following set of images demonstrates the quality and full size of an image file uncompressed and under various compression schemes. The examples are shown magnified, for comparison. The original image was captured from a 4-by-5-inch photographic transparency at a resolution of 400 spi using 24-bit color.

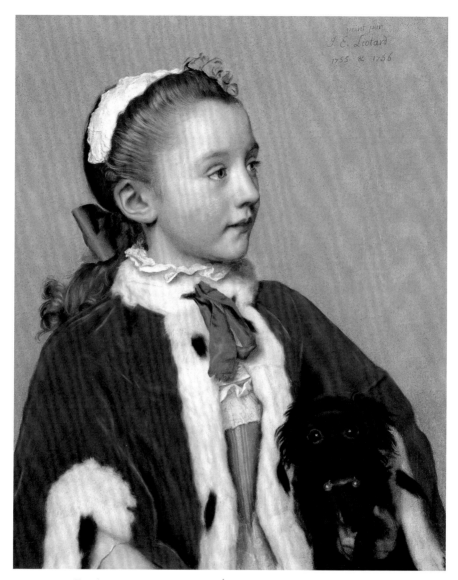

Fig. 6 (above and following pages). Jean-Étienne Liotard (Swiss, 1702–1789), *Maria Frederike van Reede-Athlone at Seven Years of Age,* 1755–56. Pastel on vellum, 57.2 x 47 cm (22 ½ x 18½ in.). Los Angeles, J. Paul Getty Museum, 83.PC.273

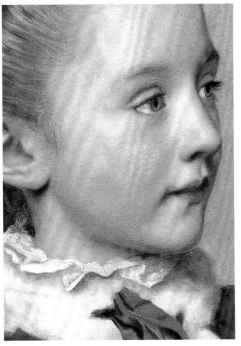

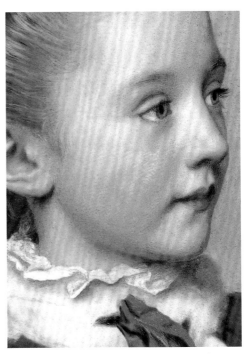

TIFF file, 18.4 megabytes (uncompressed)
TIFF is an excellent format for master files, which may be up to
four gigabytes in size and whose quality is generally limited only
by the capabilities of the capture device. Neither uncompressed
nor compressed TIFFs are ideal for Web delivery, as the files tend
to be large and not supported by all browsers.

JPEG file, 3.3 megabytes (lossy compression, 5.5:1 ratio)

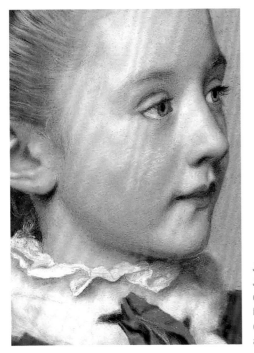

JPEG file, 488 kilobytes (lossy compression 38.6:1 ratio)
JPEGs provide high-quality lossy compression of richly colored
continuous-tone images lacking definite lines or sharp contrasts
between colors. JPEG is not ideal for images with areas of solid
color and clear edges, and at higher compression ratios can cre-
ate artifacts such as halos, "blockiness," and color banding.

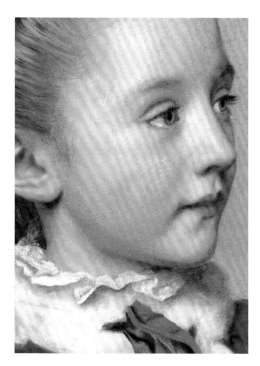

GIF file, 4.6 megabytes (lossy compression, 4:1 ratio)
A lossy-compression format best suited for images that contain clean lines and large areas of solid color, GIFs are often used to create thumbnail images and Web graphics. GIF is not recommended for continuous-tone images because it removes colors and replaces them with the nearest approximation in its limited palette.

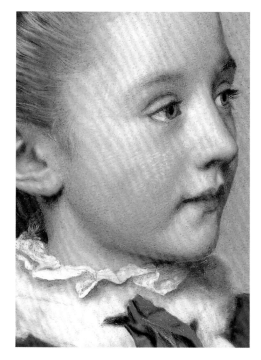

JPEG2000 file, 332 kilobytes (lossy compression, 56.8:1 ratio)
JPEG2000, though a relatively new format that is not yet widely supported, offers both lossless compression and greater lossy compression at higher quality than JPEG. JPEG2000 is best used for continuous-tone images that do not contain fine detail or "noisy" textures because at higher compression ratios it can produce artifacts such as blurriness and ringing.

Networks, System Architecture, and Storage

Nearly all digital image collections will be created and distributed to some extent over networks. A **network** is a series of points or nodes connected by communication paths. In other words, a network is a series of linked computers (and data storage devices) that are able to exchange information or can "talk" to one another, using various languages or protocols such as **TCP/IP** (Transmission Control Protocol/Internet Protocol), **HTTP** (Hypertext Transfer Protocol, used by the World Wide Web), or **FTP** (File Transfer Protocol). The most common relationship between computers, or, more precisely, between computer programs, is the **client/server** model, in which one program—the **client**—makes a service request from another program—the **server**—that fulfills the request. Another model is the **peer-to-peer** (P2P) relationship, in which each party has the same capabilities, and either can initiate a communication session. P2P offers a way for users to share files without the expense of maintaining a centralized server. Music file-sharing has made P2P both popular and controversial at the turn of the twenty-first century, with some copyright owners asserting that the technology facilitates the circumvention of copyright restrictions.

Networks can be characterized in various ways, for instance by the size of the area they cover: local area networks (**LAN**); metropolitan area networks (**MAN**); wide area networks (**WAN**); and the biggest of all, the Internet (from *Inter*national *Net*work), a worldwide system. They can also be characterized by who is allowed access to them: **intranets** are private networks contained within an enterprise or institution; **extranets** are used to securely share part of an enterprise's information or operations (its intranet) with external users. Devices such as **firewalls** (programs that examine units of data and determine whether to allow them access to the network), user **authentication**, and virtual private networks (**VPN**), which "tunnel" through the public network, are used to keep intranets secure and private.

Another important characteristic of a network is its bandwidth—its capacity to carry data, which is measured in bits per second (bps). Older modem-based systems carry data at only 24 or 56 kilobits per second (Kbps), while newer **broadband** systems can carry exponentially more data over the same time period. One of the problems faced by anyone proposing to deliver digital images (which are more demanding of bandwidth than text, though much less greedy than digital video) to a wide audience is that the pool of users attempting to access these images is sure to have a varying range of bandwidth or connection speeds to the Internet.

Many different network configurations are possible, and each method has its advantages and drawbacks. Image servers might be situated at multiple sites on a network in order to avoid network transmission bottlenecks. A digital image collection might be divided among several servers so that a query goes to a particular server, depending on the desired image. However, splitting a database containing the data and metadata for a collection may require complex routing of queries. Alternatively, redundant copies of the collection could be stored in multiple sites on the network; a query would then go to the nearest or least busy server. However, duplicating a collection is likely to complicate managing changes and updates. Distributed-database technology continues to improve, and technological barriers to such systems are diminishing. Likely demand over the life cycle of a digital image collection will be a factor in deciding upon network configuration, as will the location of users (all in one building or dispersed across a campus, a nation, or throughout the world).

Storage is becoming an increasingly significant component of networks as the amount of digital data generated and stored each day increases almost exponentially. It is often differentiated into three types: **online**, where assets are directly connected to a network or computer; **offline**, where they are stored separately (perhaps as shelved tapes or optical disks such as **CD-** or **DVD-ROMS**) and are not readily accessible; and **nearline**, where assets are stored offline but are available in a relatively short time frame if requested for online use. Nearline storage systems often use automated "jukebox" systems, where assets stored on media such as optical disks can be retrieved on demand. Other mass-storage options include magnetic tape, which is generally used to create backup copies of data held on hard disk drives, or Redundant Arrays of Independent Disks (**RAID**), which are systems of multiple hard disks, many holding the same information.

Online storage, now known also as **storage networking**, has become a serious issue as the volume of data that is required to be readily accessible increases. The essential challenge of storage networking is to make data readily accessible without impairing network performance. Two approaches to this challenge gaining currency of late are storage area

networks (**SAN**) and the less sophisticated network-attached storage (**NAS**). The two are not mutually exclusive: NAS could be either incorporated into or be a step toward a SAN system, where high-speed subnetworks of storage devices are used to hold data, thus unburdening servers and releasing network capacity for other purposes. Higher-end storage systems offer sophisticated file management that includes continuous error checking, **failover** mirroring across physically separate storage devices, and durable pointers to objects so that they can be stored once but referenced from many locations.

Whatever storage system is employed, because of the ephemeral nature of digital objects, and because no one yet knows the best preservation strategy for them, it is extremely important to keep redundant copies of digital assets on different media—for instance: CD-ROM, magnetic tape, and hard disk—under archival storage conditions and in different locations (see *Long-Term Management and Preservation*).

Part II Workflow

Why Digitize?

Before embarking upon the creation of a digital image collection, it is wise to be aware of the costs and commitment involved and ask, why undertake such a task, and for whom? Digital surrogates can almost never be considered replacements for analog originals, which have intrinsic value and compared to which even the best-quality digital image represents a loss of information—inevitably failing to convey the unique feel, scent, weight, dimension, and patina of a physical object. Moreover, the creation of digital image collections can be arduous and expensive, their maintenance can impose a long-term obligation upon institutions, and their management may well throw into question many established procedures.

The issue of whether such a commitment is worthwhile can only be resolved by considering the mission and resources of any particular institution. A digital image collection can increase awareness of, and facilitate access to, analog collections and thus serve both an educational and a promotional function. It can support the management of resources by providing, for instance, a straightforward way of identifying different assets. It can indirectly facilitate the conservation of original artifacts, because use of a digital surrogate can decrease wear and tear on the original, although it should be noted that, conversely, the additional awareness created by the availability of a digital surrogate can actually increase demand to view the original. High-quality or specialized imaging can reveal previously indiscernible details that might be useful in the conservation and/or analysis of original artifacts. Aside from all such considerations, it may be that the expectation of all cultural heritage institutions to offer digital surrogates online has reached a point where both target audiences and funding sources require its fulfillment at some level.

These incentives must be balanced against the time and expense involved in establishing and maintaining a digital image collection—factors that are all too easy to underestimate. While funding is often available for digitization projects, costs frequently go beyond the actual scanning

process to include, for instance, conservation of originals, cataloguing of originals and surrogates, photography, salaries, training, and investment in the technical infrastructure to facilitate management, preservation, and access. Because image files are so large compared to text files, the construction of a networked image repository is likely to affect system resources significantly, and system architecture and **network topology** are therefore likely to become significant concerns. License fees may be required to reproduce the chosen material and offer it over the World Wide Web or in any other digital form. Even if various tasks are outsourced to either commercial vendors or collaborative nonprofit consortia, the creation of a digital image collection will inevitably consume resources that might have been spent on some other task.

Project Planning

Once the decision has been made to create a digital image collection, its scope and form need to be tailored to the particular institution: the more time spent in review and analysis before embarking on the first scan, the more successful a project is likely to be. Remember that projects may be carried out in partnership or collaboration with other institutions or initiatives, and that this may allow sharing of both costs and expertise.

Collection Selection

The first step is to select the collection, collections, or part of a collection to be digitized. Consider the level of interest in the selection and its relevance to the scanning institution's mission. Make sure that the scale of the proposed project is practical, considering the broader technical environment: the operating systems, networks, and bandwidth in place, and overall budgets and priorities. It is advisable to think through an overall strategy but to begin with smaller projects and work up gradually to a more ambitious program.

Conservation and Access Status

Collections that are already in good condition and have consistent metadata control make for far less arduous imaging projects. Ensure that the items are not too physically fragile to withstand the imaging process without damage, and decide which scanning method is most appropriate (see *Selecting Scanners*). Appraise the collection's organization: well-organized collections facilitate a robust linking of physical object and digital surrogate through such strategies as consistent file-naming protocols, while chaotic collections do not. Maintaining such relationships between analog and digital assets is crucial for managing hybrid collections. Completing conservation and cataloguing of any selected collection before beginning the scanning process is highly recommended.

Legal Status

Discover whether any legal clearances are required to reproduce the originals or to modify and display the reproductions. Be aware that many license agreements are of limited duration, which may be a problem if the intention is that a digital image collection be available indefinitely. Projects are much more straightforward if clearance requirements are minimal, as for instance when the items to be digitized are in the public domain or the scanning institution owns reproduction rights.

Project Team and Workflow

Identify the team that will be required to complete the project. Digitizing projects generally require the expertise of many different departments and/or individuals, whose availability should be considered when plotting out the project timeline and workflow. Decide which, if any, of the many tasks involved—conservation, photography, scanning, cataloguing, metadata capture, storage—are to be outsourced. It will be necessary to review workflow constantly in order to recognize and resolve weaknesses and bottlenecks.

Standards Selection

It will be necessary to decide which imaging (file format, resolution, naming protocols, and so on) and metadata standards to employ, taking into account the nature of the original material, the staff time available for indexing and cataloguing, and the likely users of the collection. (See *Image Capture* and *Selecting a Metadata Schema*.) Certain standards may already be in place within an institution, and participating in certain partnerships or collaborations may prompt the selection of standards already in use within the larger group.

Digital Asset Management

The standards in use within the larger group may also influence the selection of hardware, software, and, perhaps most critically, an image or digital asset management (**DAM**) system. It is important to remember that DAM software cannot develop asset management strategies (though it can be used to implement or enforce them) and that whatever management system is used, its usefulness will depend on the quality of metadata it contains.

DAM systems can track digital image creation and modification, record the location of master and derivative files, allow search and retrieval of files, monitor migration schedules, control access, and so forth. Turnkey

or customizable off-the-shelf DAM systems are available at a broad range of prices and levels of complexity, and it is also possible to utilize desktop database software or more powerful client/server systems to create in-house customized solutions, or to employ some combination of commercial and in-house systems. XML-based solutions such as native-XML or **XML-enabled** databases are likely to become more popular in the future.

The most appropriate image management solution will be dictated by the available budget, the scale of the project and its projected growth, the available technical infrastructure and support, the projected demand, and similar issues. Most institutions will want to incorporate their DAM system into a general, institution-wide automation or digital library plan. This will require some level of integration with existing or planned collection and library management systems, online public access catalogues (**OPAC**), publishing systems, and perhaps business or administrative systems. The use of consistent data structure and content standards ensures flexibility by facilitating the exchange and migration of data and thus promoting interoperability and **resource sharing** within (and between) institutions.

User Requirements

All aspects of a digital imaging project will need to take into consideration the needs of each class of potential user, but these will most particularly guide decisions about presentation and delivery. Understanding user needs requires probing the assumptions of differing groups, which may be achieved through user studies. These may reveal particular requirements or limitations, such as the desired level of image quality, necessary information-searching facilities, or a predefined network infrastructure. For example, medium-resolution images of a particular collection may be sufficient for classroom use by undergraduate students, but they may contain too little information for a conservator exploring the technical construction of a work. Security protocols can be used to give different image and metadata access to the various users of a collection, if this is deemed necessary (see *Security Policies and Procedures*). It will be necessary to select which data elements should display to the various user groups, which should be searchable, and what kinds of searches should be possible.

Other requirements or preferences may also be revealed through user studies. Will users want to integrate image display with other institutional information? For example, would users want to display a record from a curatorial research database or library management system alongside the image? Will users wish to be able to integrate search results into word processing or other documents, and, therefore, should copying or downloading of the image and record be facilitated (which might have

legal implications)? Do users require thumbnail images for browsing, and, if so, what type of identification should accompany each image? Would image processing or image manipulation functions (such as changing colors, zooming, or **annotation**) be helpful to users? It may not be desirable or even possible to fulfill all such desires, but it is useful to be aware of them. (See *Delivery*.)

Digital Preservation

It will be absolutely necessary to develop a strategy for ensuring long-term access to, and preservation of, assets. This will require choosing that combination of tactics—such as documentation, **redundant storage**, **refreshing**, migration, **emulation**, and resource sharing—that best suits the institution and its resource limitations, such as storage capacity. (See *Long-Term Management and Preservation*.)

Selecting Scanners

Scanning can be done in-house or contracted out. The cost-effectiveness of each approach will depend on the volume, type, and fragility of materials being scanned, the required quality of the resulting digital objects, and the expertise and equipment available in-house. The economics of this equation will change with market conditions and technological advances. In making this decision, it can be helpful to know something about the strengths and weaknesses of the various types of scanners available, in order to assess their appropriateness for any particular imaging project or strategy. However, be aware that scanner selection is only one factor affecting the success of a digitizing project. For instance, any area where high-quality scanning will take place should have controlled lighting (no natural light) and continuous gray-tone walls, ceiling, and floor and be free of dust and vibrations. Service bureaus offering image capture vary considerably in the quality levels they provide, and should the decision be made to outsource digitization, a variety of sample images should be sent to several vendors, and the quality of the resultant scans compared before digitization is begun.

There are four general types of scanners: **drum** (fig. 9), **flatbed** (figs. 7, 10), **film** or **transparency** (fig. 11), and digital camera (essentially a traditional still camera with scanner technology attached to it, or a "scanback") (fig. 8). Most scanners use **CCD** (charge-coupled device) light-sensitive image sensors, though the newer CMOS (complementary metal oxide semiconductor) technology is making some inroads in lower-cost and lower-quality mobile applications. Scanning is a process that generally resembles photography or photocopying, and in fact it is advisable to use the services of a professional photographer for image capture, if possible, to ensure the highest possible quality of reproduction. Depending on the type of capture device, the work to be captured may be placed either in front of a digital camera (on a stand or tripod) or on or in a scanner. A shot is then taken, but instead of exposing the grains on a piece of

negative film or on a photocopying drum, light reflects off (or through) the image onto a set of light-sensitive **diodes**.

Each diode responds like a grain of film, reading the level of light to which it is exposed, except that it converts this reading to a digital value, which it passes on to digital storage or directly into computer memory for editing and other postcapture processing. Rather than exposing the entire image at once, the diodes may sweep across the source image, like the light sensors on a photocopying machine. The number of distinct readings, taken vertically and horizontally, determines the resolution of the scanned image. The possible range of values that can be recognized by the digitizing hardware is the dynamic range of the device, which helps determine the maximum sample depth of the resultant images. (As of this writing, the chosen scanner should have a minimum bit depth of 36, but a bit depth of 42 or 48 may be preferable.)

The hardware device (i.e., the scanner) functions together with its driver (the program that allows a peripheral device such as a scanner to interface with a computer's operating system) and its managing application program or software, and each of these three elements will have an impact upon image quality. It is possible to use third-party scanning and editing software for postscanning image manipulation rather than the program that comes bundled with a scanner. Such software should be chosen on the basis of its ability to perform required tasks, such as saving image files into the needed variety of formats and compression schemes (for instance, TIFF, GIF, JPEG/JFIF, PNG, JPEG2000, and LZW), or converting images from one format to another. Another important capability is **batch processing**, the ability to apply a given process—such as compression, the creation of thumbnail images, or the addition of a **watermark** or copyright notice—to multiple files. (Note that such capabilities may be needed in-house even if a service bureau does the original image capture, and also that some may be provided by DAM systems, perhaps linking to third-party software.) A manual override for any automatic scanning function

Flatbed
scanner ▷

Lamp
assembly ▷

◁ Mirror

◁ Lens array

◁ CCD chip with RGB filters

Fig. 7. Components of a flatbed scanner

Fig. 8. Digital camera attached
to an adjustable copy stand

is also essential, as any system will occasionally misjudge material. Using hardware and software that support ICC color profiles enables the scanner and monitor employed to be calibrated to the same settings and helps ensure color fidelity and consistency.

Digital cameras are the most versatile capture devices. Attached to an adjustable copy stand (similar to a microfilming stand), the camera can be moved up or down in order to fit the source material within its field of view. This allows the scanning of materials larger than most scanners can accommodate and does not require direct contact with the original, which may be an important conservation concern. Moreover, digital cameras allow more control over lighting and setup than is possible with scanners, and can also capture images of three-dimensional objects rather than being limited to documenting two-dimensional originals or analog surrogates. However, high-quality digital copy-stand cameras are expensive, and the more portable and affordable handheld consumer cameras cannot offer the same quality of image capture. The choice of a digital camera can eliminate the often-laborious workflow step of creating analog photographic intermediaries such as negatives or transparencies. This will save time but will not provide an additional, robust surrogate of the originals.

Drum scanners resemble mimeograph stencil machines from the 1960s; source material is placed on a drum that is rotated past a high-intensity light source during image capture. Drum scanners use traditional photomultiplier tube (**PMT**) technology rather than CCDs. They tend to offer the highest image quality, up to 8000 samples per

Fig. 9. Drum scanner

inch (spi), but require flexible source material of limited size that can be wrapped around a drum, which may be a serious conservation concern and may require the use of analog photographic intermediaries. Drum scanners are expensive as compared to most other scanner types. ("Virtual drum" scanners, which use CCD technology and a crafty arrangement of mirrors, are more affordable but cannot approach the same resolution.)

Flatbed scanners are highly affordable and resemble photocopying machines; source material is placed flat on the glass and captured by CCD arrays that pass below it. Newer scanners generally have a resolution of between 1200 and 5000 spi, depending on their price and quality. Flatbed scanners require source material to be no larger than the scanner's glass and to lay facedown and flat in direct contact with the scanner, thus making them impractical for fragile or oversize materials. Many flatbed scanners

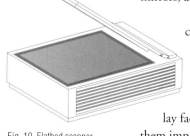

Fig. 10. Flatbed scanner

now come with built-in slide or transparency holders, and transparency adapters can be easily purchased if such devices are not included. These may allow multiple transparent images to be scanned at a time, if each image in a strip has the same color and resolution requirements. However, if one cannot invest in an expensive, top-of-the-line flatbed scanner, transparency scanners can generally achieve higher-quality image capture from transparent material.

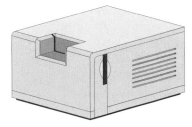

Fig. 11. Film or transparency scanner

Transparency scanners generally resemble small boxes with a slot in the side big enough to insert a 35mm slide, though multiformat or 4-by-5-inch scanners are also available. Inside the box, light passes through the transparency to hit a CCD array. Transparency scanners are designed to scan small areas at high resolution. They can offer resolution comparable to that of a mid- to high-end flatbed scanner and are highly affordable.

The nature and characteristics of the source material should be examined to determine what limitations they impose upon scanner selection. Will capture be from the original work or from a photographic reproduction? How fragile or robust is the source material? Is it transparent or reflective, two- or three-dimensional, or pliable enough to wrap around a large drum? Once the range of scanner types has been narrowed, a choice must be made among the features and capabilities of various models, noting such characteristics as ability to support ICC color profiles, maximum possible resolution, and sample depth.

Image Capture

Before embarking on image capture, the decision must be made whether to scan directly from the originals or to use photochemical intermediaries, either already in existence or created especially for this purpose. Photographic media are of proven longevity: black-and-white negatives can last up to two hundred years and color negatives for more than fifty years when stored under proper archival conditions. They can thus supply a more reliable surrogate than digital proxies. Moreover, there is some concern that the greater contact with the capture device (if using a drum or flatbed scanner) and lighting levels required for digital photography might be more damaging to originals than traditional photography, though this is changing as digital imaging technology advances. However, creating photochemical intermediaries means that both they and their scanned surrogates must be managed and stored. Moreover, when a digital image is captured from a photographic reproduction, the quality of the resulting digital image is limited both by the reproduction itself and the capability of the chosen scanning device or digital camera. Direct capture from an original work offers image quality generally limited only by the capabilities of the capture device. (See *Selecting Scanners.*) Note that different film types contain different amounts of information. For example, large-scale works, such as tapestries, might not be adequately depicted in a 35mm surrogate image but may require a larger film format (an 8-by-10-inch transparency, for instance) to capture their full detail.

Digital image quality is dependent upon the source material scanned. The following images show the relative amount of detail found in a 4-by-5-inch transparency and a 35mm slide. Over three times as many pixels compose the same portion of the image when it is scanned from the larger format at the same resolution.

Fig. 12. Joseph Nash (English, 1809–1878), *The British Nave.* Color lithograph, 66 × 84.5 cm (26 × 33¼ in.), from: *The Great Industrial Exhibition of 1851* (London: Dickinson Brothers, 1851). Research Library, The Getty Research Institute, 960088

Detail of image scanned from a 4-by-5-inch transparency and enlarged by 353%.

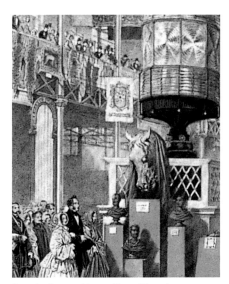

Same detail scanned from a 35mm slide and enlarged 1010%.

Compare the people and various elements in each detail. A larger photographic intermediary produces a more nuanced image.

The quality of a digital image can never exceed that of the source material from which it is scanned. Perfect digital images of analog originals would capture accurately and fully the totality of visual information in the original, and the quality of digital images is measured by the degree to which they fulfill this goal. This is often expressed in terms of resolution, but other factors also affect the quality of an image file, which is the cumulative result of the scanning conditions (such as lighting or dust levels); the scanner type, quality, and settings; the source material scanned; the skill of the scanning operator; and the quality and settings of the final display device.

Digitizing to the highest possible level of quality practical within the given constraints and priorities is the best method of "future-proofing" images to the furthest extent possible against advances in imaging and delivery technology. Ideally, scanning parameters should be "use-neutral," meaning that master files are created of sufficiently high quality to be used for all potential future purposes. When the image is drawn from the archive to be used for a particular application, it is copied and then optimized for that use (by being compressed and cropped for Web presentation, for instance). Such an approach minimizes the number of times that source material is subjected to the laborious and possibly damaging scanning process, and should emerge in the long term as the most cost-effective and conservation-friendly methodology.

A key trade-off in defining an appropriate level of image quality is the balancing of file size and resulting infrastructural requirements with quality needs. File size is dictated by the size of the original, the capture resolution, the number of color channels (one for gray-scale or monochromatic images; three—red, green, and blue—for color images for electronic display; and four—cyan, magenta, yellow, and black—for offset printing reproduction), and the bit depth, or the number of bits used to represent each channel. The higher the quality of an image, the larger it will be, the more storage space it will occupy, and the more system resources it will require to manage: higher bandwidth networks will be necessary to move it around; more memory will be needed in each workstation to display it; and the scanning process will be longer and more costly. (However, remember that smaller, less demanding access files can be created from larger master files.)

Before scanning begins, standardized color reference points, such as **color charts** and gray scales, should be used to calibrate devices and to generate ICC color profiles that document the color space for each device in a digital media workflow. Color management is a complex field, usually requiring specialists to design and implement a digital media environment, and extensive training and discipline are required to maintain the consistent application of color quality controls. If such expertise is not

affordable or available, color management systems that support ICC profiling are obtainable at a wide range of prices, as are color-calibration tools. Including a color chart, gray scale, and ruler in the first-generation image capture from the original, whether this is photochemical or digital, provides further objective references on both color and scale (fig. 13). Do not add such targets when scanning intermediaries, even when this is possible (a slide scanner, for instance, could not accommodate them), because doing so would provide objective references to the intermediary itself, rather than the original object.

Fig. 13. KODAK Q-13 Color Separation Guide (shown half-size)

To allow straightforward identification of digital images and to retain an association with their analog originals, all files should be assigned a unique, persistent identifier, ideally in the form of a file name based upon the identifier of the original, such as its accession or bar code number. A naming protocol that will facilitate the management of variant forms of an image (masters, access files, thumbnails, and so forth) and that does not limit cross-platform operability (for instance, by using "illegal" or system characters) of image files must be decided upon, documented, and enforced.

Master Files

Archival master images are created at the point of capture and should be captured at the highest resolution and greatest sample depth possible (ideally 36-bit color or higher). These will form the raw files from which all subsequent files will be derived. After the digitization process, there is generally a correction phase where image data is adjusted to match the source media as closely as possible. This may involve various techniques, including color correction—the process of matching digital color values with the actual appearance of the original—and other forms of digital image preparation, such as cropping, dropping-out of background noise, and adjustment of brightness, contrast, highlights, or shadow, etc. The most common correction-phase error is to make colors on an uncalibrated monitor screen match the colors of the original. Great care must be taken to use standard technical measurements (such as "white points") during the correction process, which will create the **submaster,** or **derivative master,** from which smaller and more easily delivered access files are generated.

It will be up to the individual institution to decide whether to preserve and manage both archival and derivative masters, or only one or the other, for the long term. Constant advances in fields such as color restoration are being made, and if the original raw file is on hand, it may be returned to if it turns out that mistakes were made in creating the derivative master. However, it may be expensive and logistically difficult to preserve two master files. The final decision must be based on the existing digital asset management policy, budget, and storage limitations. Whatever the decision, editing of master files should be minimal.

Ideally, master files should not be compressed; as of this writing, most master images are formatted as uncompressed TIFF files, though an official, ratified standard that will replace TIFF is likely to appear at some point in the near future. If some form of compression is required, lossless compression is preferred. The files should be given appropriate file names so that desired images can be easily located.

Image metadata should be immediately documented in whatever management software or database is utilized. The process of capturing metadata can be laborious, but programs are available that automatically capture technical information from file headers, and many data elements, such as scanning device, settings, etc., will be the same for many files and can be added by default or in bulk. The masters should then be processed into the chosen preservation strategy, and access to them should be controlled in order to ensure their **authenticity** and integrity. (See *Long-Term Management and Preservation*.) It is possible to embed metadata, beyond the technical information automatically contained in file headers, in image files themselves as well as within a database or management system. Such redundant storage of metadata can serve as a safeguard against a digital image becoming unidentifiable. However, not all applications support such embedding, and it is also conceivable that embedded metadata could complicate a long-term preservation strategy.

Access Files

Generally, master images are created at a higher quality than is possible (because of bandwidth or format limitations) or desirable (for reasons of security, data integrity, or rights protection) to deliver to end users, and access images are derived from master files through compression. All access files should be associated with appropriate metadata and incorporated into the chosen preservation strategy, just as master files are. In fact, much of the metadata will be "inherited" from the master file. Almost all image collections are now delivered via the Web, and the most common access formats as of this writing are JPEG and GIF. Most Web browsers support these formats, so users are not required to download additional viewing or

decompression software. Each institution will need to determine what quality of access image is acceptable for its various classes of users and measure this decision against the cost in resources for image creation, delivery, and storage.

Web-based distribution using browser-supported file formats is the most common and broadly accessible way of distributing images, but it does impose certain limitations, especially if there is a desire to offer higher-quality, and therefore larger, images. For instance, delivering images to users accessing the Internet through a 56 Kbps modem will necessitate small (highly compressed) images to prevent those users' systems becoming overburdened. The general adoption and support of more efficient compression formats (see *File Formats*) and a wider adoption of broadband technology may go a long way toward remedying this situation. In the meantime, another option is to use a proprietary form of compression that requires special decompression software at the user's workstation. An example of such a compression system is MrSID, which, like JPEG2000, uses wavelet compression and can be used to display high-quality images over the Internet. However, the usual caution that applies to proprietary technology should be applied here: legal and longevity issues may emerge.

Another strategy is to provide smaller compressed images over the Web or some other Internet-based file exchange method but then require users to go to a specific site, such as the physical home of the host institution, to view higher-quality images either over an intranet or on optical media such as a CD- or DVD-ROM. This option may be a useful stopgap solution, providing at least limited access to higher-quality images. There may be other reasons for offering images and metadata on optical or other media besides (or instead of) over the Web, such as restricted Internet access in certain countries.

Selecting a Metadata Schema

There are many metadata schemas available, geared to different communities and to different needs. Metadata schemas are defined ways of structuring metadata elements; in other words, they are used to structure information or data. The idea behind the development of metadata schemas is to promote consistency and uniformity of data so that it can be easily aggregated, moved, shared, and ultimately used as a resource discovery tool or for other purposes. Participation in resource-sharing or collaborative initiatives often requires the adoption of particular metadata schemas.

One of the complicating factors in documenting hybrid collections is that there are likely to be many versions of one object, and their relationships to each other must be recorded. For instance, a collection might include an original painting, a photochemical surrogate of the painting (such as a 4-by-5-inch transparency), and several digital surrogates derived from the transparency: the archival master, the derivative master, and one or more access files. Some metadata schemas provide 1:1 documentation of each version, while others are hierarchical, designed to provide information on parent, child, and peer relationships without requiring that each instance be separately and fully catalogued. In fact, many schemas that were originally intended to provide 1:1 documentation are now being extended to accommodate this new reality, but the exact manner in which this is done varies and is again the subject of current research.[3] Broadly speaking, developers and users of documentation for image collections distinguish between information that refers to the original work, information that refers to analog or digital representations of that work, and information that refers to the technical characteristics of a digital image (which may have been captured from the original or from a photographic representation or derived from an existing digital image file) (fig. 14). They also distinguish between

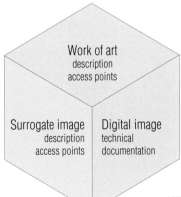

Fig. 14. Model of metadata required to document a work and its surrogates

Work of art
description
access points

Surrogate image
description
access points

Digital image
technical
documentation

schemas designed to describe individual items and collections as a whole. Various schemas may be used together to provide complete documentation of an item or collection.

MARC (Machine-Readable Cataloguing) is a venerable metadata standard long used for creating bibliographic records. It supports the Anglo-American Cataloguing Rules (AACR2) and allows the exchange of cataloguing information within the library community. MARC has been enhanced over the years to, for instance, accommodate the cataloguing of nonbibliographic material, represent authority information, and include elements to describe electronic resources. The Library of Congress and the MARC Standards Office have developed an XML schema, the Metadata Object Description Schema (**MODS**), designed to both transmit selected data from existing MARC 21 records (so-called because they result from the harmonization of the Canadian and U.S. MARC formats in readiness for the twenty-first century) and enable the creation of original resource description records.

EAD (Encoded Archival Description) is a set of rules for creating finding aids for archival collections that specify the intellectual and physical arrangement of an intact or cohesive collection as a whole. EAD finding aids may be linked to item-level records that exploit **Dublin Core** or some other schema. EAD uses **SGML** (Standard Generalized Markup Language) to define its logical structure (see *Metadata Format*).

Dublin Core, developed as a core set of semantic elements for categorizing Web-based resources for easier search and retrieval, has become popular in the museum and education communities. The schema is deliberately simple, consisting of fifteen optional, repeatable data elements, designed to coexist with, and map to, other semantically and functionally richer metadata standards. Dublin Core's simplicity makes it an excellent medium of exchange, and thus a basis for interoperability. The metadata harvesting protocol of the Open Archives Initiative (**OAI**), known as OAI-PMH, which provides a mechanism for harvesting or gathering XML-formatted metadata from diverse repositories, mandates Dublin Core as its common metadata format. The Dublin Core Metadata Initiative (**DCMI**) is also developing administrative and collection-level metadata element sets, and user communities have developed element qualifiers relevant to their own fields, which both enrich and complicate the standard.

CDWA (*Categories for the Description of Works of Art*) provides a framework for describing and accessing information about artworks and their visual surrogates. It identifies vocabulary resources and descriptive practices intended to make information held in diverse systems both more compatible and more accessible. The Visual Resources Association (VRA) Data Standards Committee expanded upon certain portions of the CDWA to formulate the **VRA Core Categories**, which are specifically designed to

describe the attributes of not only original works but also surrogates in considerable detail. This makes the VRA Core Categories particularly useful in documenting digital image collections.

The Research Libraries Group's (**RLG**) **Preservation Metadata Elements** are intended to set out the minimum information needed to manage and maintain digital files over the long term and, unlike the schemas described above, capture technical, rather than descriptive, information. This element set may be combined with any descriptive element set to describe an image file.

The NISO *Data Dictionary: Technical Metadata for Digital Still Images* provides an exhaustive list of technical data elements relevant to all aspects of digital image management: preservation, production, display, use, and processing. In contrast to the RLG preservation elements, which can be applied broadly to many types of digital files, the *Data Dictionary* focuses only on digital still images. The Library of Congress and NISO have developed an XML schema known as NISO Metadata for Images in XML, or NISO **MIX**, based upon the dictionary.

MPEG-7, or Multimedia Content Description Interface, is an XML-based standard developed by the Motion Picture Experts Group (**MPEG**) to describe multimedia and audiovisual works and is likely to grow in importance over the next few years. It supports textual indexing (e.g., the use of controlled vocabularies for data elements such as subjects and genres) and nontextual or automatic indexing, such as shape recognition and color histogram searching. It also supports hierarchical or sequential description.

These are only a few of the metadata schemas available. Other metadata standards that might be of interest to the cultural heritage community include the *International Guidelines for Museum Object Information: The **CIDOC** Information Categories*, developed by the International Committee for Documentation (**CIDOC**) of the International Council of Museums (ICOM). The International Council of African Museums (**AFRICOM**), originally a program of ICOM, has developed a data standard initially designed to promote the standardization of collection inventories in Africa, described in the *Handbook of Standards: Documenting African Collections*.[4] **Object ID** sets out the minimum information needed to protect or recover an object from theft and illicit traffic. **SPECTRUM**, developed by the UK-based mda (formerly the Museum Documentation Association), is comprised of a broad range of data elements associated with transactions for museum objects. CIMI (the Consortium for the Interchange of Museum Information) and the mda have developed an XML schema based on the SPECTRUM elements.

Broader systems are being developed that are designed to join the seeming morass of cultural heritage documentation, including the various

metadata schemas, into a coherent whole, though many remain untested as of this writing. The CIDOC object-oriented Conceptual Reference Model (**CRM**), which took the CIDOC Information Categories as its starting point, is designed to mediate between disparate information sets by describing in a prescribed, extensible "semantic language" their explicit and implicit concepts and relations, thus promoting semantic interoperability. It focuses primarily on museum objects rather than digital surrogates but can be extended to allow for detailed description of such surrogates, for instance, by being combined with another metadata schema such as MPEG-7. The Metadata Encoding and Transmission Standard (**METS**) is a flexible XML encoding format for digital library objects that may be used within the Open Archival Information System (**OAIS**) reference model. METS provides a metadata "**wrapper**" that can hold together descriptive, administrative, and structural metadata and document the links between them, as well as capturing multipart file groups and behaviors. Its generalized framework offers a syntax for the transfer of digital objects between repositories, while OAIS provides a common conceptual framework in which to understand the archiving of digital assets. (See *Long-Term Management and Preservation*.)

Metadata Format

While there are many ways to format the information captured by metadata schemas (see *Metadata*), the use of XML is becoming increasingly dominant. Like the more familiar **HTML** (Hypertext Markup Language), XML is a markup language derived from SGML. However, while HTML is designed to merely present data (as of this writing, it is used to format most Web pages), XML is intended to describe data: it is a hardware- and software-independent format that allows information to be structured, stored, and exchanged between what might otherwise be incompatible systems. XML gives users the ability to generate uniformly structured metadata packages that can be used for sharing; migrating; publishing to the Web; or archiving—such as for **ingest**, storage, and delivery in open archive environments. Even if metadata is not originally encoded in XML, it is likely that at some future point the need will arise to migrate or export it to this format, in order to maximize interoperability (many software manufacturers now support converting data into XML).

SGML is a complex standard that provides a set of rules for specifying a document markup language or tag set or for defining which coded tags and attributes may be used to describe a document's content. Such specifications are given in **DTD**s (Document Type Definitions); HTML is in fact a particular DTD, which Web browsers are designed to

compile. HTML's tags are predetermined and largely limited to specifying format and display. By contrast, XML is a simplified subset of SGML. XML is "extensible" and flexible because its tags are unlimited, and thus anyone can invent and share a set of coded tags for a particular purpose, provided they follow XML rules.

XML and related tools can make semantic elements (such as "author" or "title") within documents **machine-readable** (i.e., allow documents to be parsed, effectively "understood," and acted upon by computer programs). XML documents are therefore potentially much more powerful than simple text documents. They are self-defining because they can refer to any DTD or **XSD** (XML Schema Definition), a more recently developed standard, to describe their data. DTDs or XML Schemas can define conditions such as whether a particular element is required, repeatable, or optional or express hierarchical complexity, such as parent, child, or group relationships. As compared to DTDs, XML Schemas facilitate information exchange between databases because they provide more sophisticated ways of structuring content and declaring data types. XML "namespaces" provide a means of distinguishing between duplicate element type and attribute names—derived, for instance, from different DTDs—and allow them to be used in the same document. Style sheets written in **XSL** (Extensible Stylesheet Language) dictate which XML data elements to show and how to display them. Extensible Stylesheet Language Transformations (**XSLT**) provides a standard way to reorganize the data represented in one XML document into a new XML document with a different structure or into another format altogether.

While XML is much more structured than HTML, the two are complementary; an XML Schema or DTD defines metadata elements that can be formatted for display using HTML or other formatting languages. **XHTML** (Extensible Hypertext Markup Language) is a reformulation of HTML as an application of XML designed to express Web pages and may be extended to include new elements.

XML could become even more powerful if routinely combined with RDF, which provides a model for describing Web resources that promotes a consistent representation of semantics. RDF effectively functions as a crosswalk between diverse metadata schemas and could allow structured metadata developed in different contexts to be exchanged and reused without loss of meaning. RDF provides a foundation for the machine processing of Web resources because it promises metadata interoperability across different resource-description communities and different applications. XML and RDF are both key components of the **Semantic Web,** the intelligent evolution of the World Wide Web proposed by its inventor, Tim Berners-Lee, but as yet not realized.[5]

Quality Control

Quality control must be maintained throughout the life cycle of an image collection. Routines must be developed to verify both documentation (description, indexing, and metadata capture) and image capture and maintenance. Time and labor limitations may mean that it is only feasible to spot-check projects, in which case the frequency of such checks must be decided: for instance, one image in every ten, or every hundred, will be scrutinized.

Consistent image-capture guidelines and parameters should be established, and scans must be periodically reviewed and checked for accuracy, ideally against the source material, whether they are produced in-house or supplied by a vendor. Although automatic scanning is generally consistent, problems with exposure, alignment, and color balance occur often enough to require a quality-control component in any scanning program. Without quality control, it will not be possible to guarantee the integrity and consistency of the resulting digital image files. Steps should be taken to minimize the variations between different operators and different scanning devices. The operator and device, as well as the settings used, should be recorded for each scan; this can normally be done in bulk, and standardized settings can be developed for certain categories within the collection. Records need to be proofread and mechanisms such as controlled vocabularies utilized to ensure consistent data entry. Additionally, relationships between cataloguing records and image files need to be verified and/or developed.

Quality control must also be applied to all access files derived from master images and to all preservation copies made, on whatever media, as mistakes and technical errors can often be introduced during the process of duplication or migration. Files should be checked to ensure that all are correctly named, not corrupted, and so on. Files should then be stored in a secure archival environment that safeguards their authenticity and integrity, and quality checks should be incorporated into a long-term management plan and performed on a regular basis. There are various ways

of ascertaining whether files have somehow been altered or corrupted; one method is to document and periodically compare **checksums**—the exact number of bits in a file at its most basic, or actual values and patterns of data using more complex checksum algorithms. Again, such measures require that adequate preservation and technical metadata be stored along with the image files. When selecting a networked storage solution, evaluate software management capabilities for error checking and file refreshing. CD-ROM error-checking software is also available. (See *Networks, System Architecture, and Storage* and *Security Policies and Procedures.*)

Delivery

The investment in creating a digital image collection will be wasted if the chosen delivery method is ineffective. Successful delivery will depend on a number of elements, including user requirements, **interface** design, the consistency and quality of metadata, the choice of image-management or presentation software, and technical infrastructure. Almost all digital image collections are now distributed via the Web, even when they are intended for internal use. Beyond that common feature, delivery solutions vary greatly in complexity, performance, and cost and include the option of contributing images and metadata to a collaborative initiative that offers material from several different institutions. This has the advantage of transferring the burden of providing access to a third party but the disadvantage of allowing minimal or no customization and requiring some abdication of control. It is also possible, and increasingly common, to both independently offer a collection and simultaneously contribute it to one or more collective ventures, with each targeting a different user group.

The simplest and least technologically demanding way of delivering material is to generate static Web pages, but this will not provide sufficient functionality for many institutions, which will require some level of dynamic, interactive interface. The interrogation of an image collection's metadata then becomes a central issue. There is no single, perfect delivery solution; the chosen system should take into account the audience, the size of the collection, the complexity of its metadata, the predicted level of demand and performance expectation, and security and intellectual property requirements. Images and metadata may be contained in a single database or spread across a number of integrated systems. Some image-management systems, usually the less powerful desktop variety, are all-in-one solutions that include a Web publication module and largely predetermine how images can be shown and searched. Others, usually the more powerful solutions, do not come in a single package but require the separate selection of a **search engine**, an underlying database, and perhaps a Web delivery mechanism and other components. These

allow greater flexibility and customization. However, the more idiosyn-
cratic the solution, the greater the technical support it will require and
the more difficult it will be to maintain in the long term. Standard sys-
tems, **open architecture**, and the documentation of all customization
and integration are strongly recommended.

Web delivery requires connecting the client's browser, a Web
server, and an underlying database (the image management system). A
common method for achieving this is the use of **CGI** (Common Gateway
Interface) scripts; alternatives include **JSP**, **PHP**, and the Microsoft-specific
ASP. These all involve queries being entered on the client via a Web page
and executed on the Web server before results are passed back to the client
browser. Whichever method is chosen depends on the database software,
the complexity of data, and the available programming skills.

The search engine used in the delivery of any collection, whether
included in a complete image-management solution or chosen separately,
should be selected on the basis of its ability to fulfill identified needs, such
as performing keyword, truncated-term, **Boolean**, or natural-language
searches. It may also be important that the search engine be able to link
to complementary resources, integrate a controlled vocabulary, or search
across different data formats, different metadata schemas, or different
repositories. Another feature to consider is whether the search engine sup-
ports an information retrieval protocol, such as **Z39.50**. Such protocols
provide the communication between the client user-interface and the
search engine residing on the server and permit searching across multiple
servers without the user having to learn the search syntax of each server.
(Z39.50 is not the only such technology, and it has been criticized as overly
complex and not well adapted for the Web environment. However, it is
well established in the library and archival community.)

Note that there are two search-engine issues significant for suc-
cessful delivery of images online: the ability of users to search the collec-
tion itself (discussed above) and the ability of external search engines such
as Google, Alta Vista, and the like to discover the site and collection. Sites
may be registered with such search engines, and it is also possible to opti-
mize a site for discovery by external search engines by such measures as
populating **meta tags** with appropriate descriptions and keywords. (Google
is unusual in that it does not read meta tags, but only title tags and Web
page text.) A number of metadata harvesting initiatives have experimented
with ways of making the deep metadata buried within collections systems
more accessible to generalized search engines.

The technological capabilities of user workstations (operating
systems, chosen browser, internal memory, storage, display quality, net-
working capability, and speed) accessing the Web are sure to be highly
variable. Access to digital image collections should be tested using both

more and less powerful modes of connecting to the Internet and with Macintosh and IBM-compatible or Wintel personal computers using various browsers, because images do not display uniformly across different platforms, and different versions and types of browsers have diverse idiosyncrasies. Remember that although it is not possible to control the quality or calibration of user monitors, it is possible to provide guidelines on optimal viewing parameters. Testing should also analyze and adjust the design of the access interface for maximum ease of use. Interface design should take into account accessibility for the disabled and aim to be as inclusive as possible. Many funding agencies require adherence to federal guidelines on Web accessibility.

Security Policies and Procedures

The great strength of the Internet—the fact that it can connect people all over the world to data stored in remote servers—is also one of its weaknesses; it is difficult to prevent people from accessing data that is intended to be secure and/or private. Concerns about data integrity, authenticity, and security are not unique to image management but are common to the management of all types of networked information resources. A digital image collection should be built within a framework of institutional security policies and procedures that address all aspects of the creation, modification, manipulation, access, and use of data. For instance, the original state of files should be documented to provide benchmark values or checksums that can be inspected to verify that data has not been altered or become corrupted. Such guidelines will protect the investment in the creation of both images and metadata and guarantee the usefulness of the collection as a future resource. (See *Long-Term Management and Preservation.*)

There are several, not mutually exclusive, strategies that can be used to ensure the security and integrity of digital information. The most common security model employed by cultural heritage institutions is for access to archival master files to be limited, and for lower-quality derivative access files, delivered with a clear copyright statement, to be made generally available over the World Wide Web. Watermarks, formed by switching particular bits in a digital image, can "brand" image files and enable an image rights holder to verify the source of a digital image and seek legal recourse if it is misused or if access restrictions are violated. It is also possible to make it difficult for users to download images from the Web by, for instance, requiring users to download **plug-ins** that control printing and downloading options before allowing them to view an image.

It is possible to build systems that are designed to enforce legal restrictions—ones that can, for example, track the frequency of use of each image, make users sign in, or require them to acknowledge restrictions on use. However, such systems may be too onerous for the available level of technical support and perhaps too restrictive where the institutional

mission is to provide broad public access to collections. Where it is neces-
sary to restrict access, firewalls, **DMZs** (demilitarized zones), access control
lists (**ACLs**), and **directory** services can stand at the gateway of secure net-
works and control admission, perhaps allowing access only to those users
visiting from certain **domain names** or **IP addresses**. By implementing
features such as **passwords, digital signatures,** or **digital certificates,**
authentication may be used to ensure that potential users are indeed who
they claim to be, and specific types of users may be limited to viewing cer-
tain images under particular conditions or have their ability to alter or
delete information restricted. One scenario might be that staff is granted
editorial access to administrative metadata and master images; that inter-
nal users are granted read-only access to descriptive metadata and high-
resolution derivative images; and that external users, limited by bandwidth
and legal considerations, are granted access to the same descriptive metadata
but lower-resolution images. Digital rights management (**DRM**) server
software may use various techniques to protect and control distribution
of commercial content offered over the Web.

Security strategies can complicate the management and preserva-
tion of digital image collections and should only be instituted where they
are realistically necessary. Be wary of technological "magic bullets" claim-
ing to solve security problems. Advances in security technology may be
taken as a challenge by **hackers**, although most digital image collections
are probably less at risk from malicious unauthorized access than acciden-
tal deletion or manipulation. (Note that a common security mistake is for
network administrators to forget to change the default password of security
software.) Some security strategies, such as **public-key encryption** and dig-
ital certification, merely transfer risk to a third party and can only be
as robust as that third party is trustworthy, competent, or prescient.

Long-Term Management and Preservation

Digital assets are inherently fragile and are threatened by media instability and format and hardware obsolescence. There are many fundamental problems that can imperil digital information, for instance, that practices undertaken to solve short-term problems—compression or **encryption**, for instance—may result in an inability to "unscramble" information in the long term; that digital works are often complex, and tracking their interrelations and determining their boundaries over the long term are likely to be difficult; that a lack of clarity about whose responsibility it is to preserve digital material leaves it vulnerable to falling through the cracks and becoming inaccessible to future generations; and that translating digital information into new environments often entails some change in meaning.[6] This means that it is vital to develop a preservation strategy at the very beginning of the life cycle of a digital image collection if it is to be retained as useful and valuable in the long term. Oya Y. Rieger has identified four goals for **digital preservation**: (1) bit identity, ensuring files are not corrupted and are secured from unauthorized use and undocumented alteration; (2) technical context, maintaining interactions with the wider digital environment; (3) provenance, maintaining a record of the content's origin and history; and (4) references and usability, ensuring users can easily locate, retrieve, and use the digital image collection indefinitely.[7]

The key to digital preservation is the establishment of a managed environment. The default fate of analog objects is, arguably, to survive (think of cuneiform tablets or papyrus scrolls), but without persistent and regular intervention it is the fate of digital works to perish. Digital preservation necessitates a paradigm shift—from one where we subject objects to one-time or occasional conservation treatments then leave them, perhaps for decades, in a temperature- and humidity-controlled warehouse—to a new approach where we, for example, periodically review each work and copy it onto a new storage medium, in all likelihood more than once per decade. Digital works require ongoing management. All current digital

preservation strategies are flawed, or at best speculative, and thus a broad-based strategy is the best current safeguard of any investment in digital imaging. Over time it will be necessary to be vigilant as to both the condition of the data and technological trends and to be prepared to reassess policies accordingly. It will also be essential to have a long-term commitment to staffing, continuous quality control, and hardware, storage, and software upgrades.

The primary preservation strategy is to practice standards-driven imaging. This means, first, creating digital image collections in standard file formats at a high enough quality to be worth preserving, and second, that sufficient documentation is captured to ensure that the images will continue to be usable, meaning that all necessary metadata is recorded in standard data structures and formats. One complication here is that it is as yet unclear exactly what all the necessary metadata for digital images is; some commentators are concerned that too little metadata is captured, others that too much is. The RLG preservation metadata elements are intended to capture the minimal information needed to preserve a digital image. Various groups have developed broader protocols or frameworks for digital preservation, such as the OAIS model discussed below.

The secondary preservation strategy is redundant storage: images and metadata should be copied as soon after they are created as is practicable. Multiple copies of assets should be stored on different media (most commonly, hard disks; magnetic tape, used for most automatic backup procedures; and optical media such as CD-ROMs) and in separate geographic locations; one of the most common causes of data loss is fire or water damage to storage devices in local mishaps or disasters. All media should be kept in secure archival conditions, with appropriate humidity, light, and temperature controls, in order to prolong their viable existence; additionally, all networked information should be protected by security protocols.

Such redundancy is in accordance with the principle that "lots of copies keep stuff safe," formalized by the LOCKSS system designed at Stanford University Libraries to safeguard Web journals. Refreshing, or the periodic duplication of files in the same format to combat media decay, damage, or obsolescence, essentially extends this principle. As yet, no robust preservation medium for digital data that is practical for general use has emerged. Because of the availability of analog media of proven longevity, some researchers suggest a hybrid approach to preservation, in which digital material is derived from analog material (such as photochemical intermediaries) or, alternatively, analog backups or copies of digital material are created. (In this context it is interesting to note the Rosetta Project, which aims to provide a near-permanent archive of one thousand languages by recording them—as script readable with a powerful

microscope rather than binary code—on micro-etched nickel disks with a two-thousand-year life expectancy.[8])

Migration, the periodic updating of files by resaving them in new formats so they can be read by new software, is where preservation starts to become more problematic. Reformatting allows files to continue to be read after their original format becomes defunct, but it involves transforming or changing the original data, and continued transformation risks introducing unacceptable information loss, corruption, and possible loss of functionality. One suggested method of mitigating this problem is **technology preservation**, which involves preserving the complete technical environment necessary to access files in their original format, including operating systems, original application software, media drives, and so forth. However, it is unlikely that this approach will allow the maintenance of viable systems over long periods of time.

Emulation takes the alternative approach of using software to simulate an original computer environment so that "old" files can be read correctly, presuming that their bit streams have been preserved. Emulation is a common practice in contemporary operating systems—for instance, code can be written to make programs designed for IBM-compatible or Wintel personal computers run on Macintoshes as they would in their native environment or to make programs designed for previous versions of an operating system function in newer versions. Research into emulation as a preservation strategy is ongoing. The initial research direction sought to emulate the entire original hardware and software environment and the functionalities it offered. More recent approaches have suggested that it is more economically feasible to use emulation to provide a viewing mechanism only, and that some loss of functionality is acceptable.

Emulation holds out the seductive possibility of preserving the original "look and feel" of archival data, but its large-scale practicality remains to be demonstrated. However, it has already had some success as a tool used in **digital archaeology**—the various methods and processes undertaken to recover data from damaged or obsolete media or hardware, defunct formats, or corrupted files when other preservation strategies have failed or perhaps never been attempted. Emulation was used to revive the BBC's *Digital Domesday Book*, an extremely ambitious project stored on 1980s-era interactive videodiscs that became inaccessible within fifteen years, in 2002. (The original Domesday Book, a record of William the Conqueror's survey of England compiled in 1086 by Norman monks, remains in good condition.) Emulation has also been moderately successful in reviving obsolete arcade videogames, re-creating solely through software the experience created by their original hardware-specific environments.

Re-creation is a concept developed in the world of born-digital multimedia or installation art. It postulates that if artists can describe their work in a way that is independent of any platform or medium, it will be possible to re-create it once its current medium becomes extinct. Such a description would require the development of a standard way of describing digital art analogous to musical notation.

All or some combination of these strategies can be carried out in-house, transferred to a third party such as a commercial data warehouse service, or done in collaboration with other groups and institutions through commercial or nonprofit resource-sharing initiatives. Resource sharing may be the only practical way to conduct preservation for many institutions in the long term. Examples of such initiatives include the OCLC (Online Computer Library Center, Inc.) digital archival service and the UK-based AHDS (Arts and Humanities Data Service) data deposit service, both of which provide long-term management, access, and preservation of digital assets. Transferring risk and responsibility to a third party, however, does not by itself guarantee preservation—the third party must be reliable and likely to continue in existence. *Trusted Digital Repositories: Attributes and Responsibilities,* a report written by RLG-OCLC in 2002, describes some of the characteristics that would be required in such a storage facility.

The OAIS reference model can potentially provide a common conceptual framework for the preservation and access of digital information, and thus a common ground for discussion, collaboration, and research in these areas. The model distills the entire life cycle of digital objects, from ingest through storage and display, down to a fundamental set of functions, relationships, and processes. It rests upon the central concept of "information packages," meaning the data or bit stream itself and the "representation information" that allows the interpretation of the bit stream as meaningful information. These may be regarded as analogous to the concepts of data and metadata.[9]

In reality, no one yet knows what the best preservation strategy or combination of strategies will be. Whichever is chosen, it will be necessary to run regular—annual or biannual—checks on data integrity and media stability and to be prepared to enter into a migration program within five or so years. It is advisable to retain original files over the long term if this is possible, but this will make further demands upon management and storage capacity. Master files should be afforded the maximum possible protection. Constant vigilance and the consistent use of open standards and system-independent formats, where possible, will be the best guarantee of the long-term viability of a digital image collection.

Conclusion

Digital technology has advanced remarkably in the last several years, and the future holds the possibility of even more startling developments. The Semantic Web could transform the World Wide Web into a global database whose content is meaningful to both people and computers. Autonomic computers could learn to run themselves. Holographic storage could allow laser beams to be used to store computer-generated data in three dimensions and exponentially increase storage capacity. Automated policy-based management algorithms could make the administration of digital image collections, and indeed of almost all aspects of life, less arduous and more efficient.

However, these and many other possibilities will not come into being unless they are able to handle heterogeneity and change: the diverse platforms, operating systems, devices, software, formats, and schemas that exist in today's networked environment. Perhaps paradoxically, the best way of achieving this is through the application of open standards, not so much to remove heterogeneity—though there will certainly be an element of that—but to navigate intelligently through it, or perhaps to provide intelligent translation between heterogeneous elements. The consistent application of standards will be an essential component of advances in integration technology that might bring into being some form of the "information fusion" that the more romantic among us expect from scientific advance. At the very least, we can hope for assimilation of the functions of the myriad management systems offered today (document management, image management, digital asset management, media asset management, content management, library management, and so on) into more unified systems. More immediately, documentation standards for images must be refined and consensus built around such issues as the range of data elements that constitute a minimal image description, the most effective data structure, and so forth.

There are a number of other issues that also require further research, such as the development and adoption of accepted strategies

for preservation repositories. Technologies affecting Web accessibility, such as bandwidth and wireless transmission, will continue to be an issue if the Web is to become truly global. Delivery technology that is sensitive to the client environment (display capabilities, decompression software/hardware, etc.) might only send images with a dynamic range within a client workstation's display capability or might only send compressed images in formats the client workstation is capable of decompressing. To achieve this, image servers would need to receive descriptions of client workstations in a standard way so that only meaningful information would be transferred to a user's workstation. Issues of intellectual property on the Web are also being constantly contested, and generally accepted standards of what is and what is not permissible have yet to emerge.

Digital imaging has already provided wider access to the world's cultural heritage than ever before: images and metadata can be distributed over worldwide or local networks and can be used for many different purposes, from enhancement of scholarship and teaching to personal exploration and enjoyment. The potential for developing new audiences and broadening cultural appreciation is far-reaching. In order to take full advantage of these opportunities, however, digital image collections must be constructed to remain relevant and accessible beyond a single, short-term project. Careful choices in technology and the use of shared technical and descriptive standards will make it possible to exchange information among databases and across networks and promote collaboration and resource sharing. Standards-driven approaches will ensure that all cultural heritage institutions can participate fully in the creation of the universal virtual museum.

Notes

1. The Digital Library Forum, *A Framework of Guidance for Building Good Digital Collections* (Institute of Museum and Library Services, 2001). Available only on the World Wide Web at <http://www.imls.gov/pubs/forumframework.htm>.

2. See Murtha Baca, ed., *Introduction to Metadata: Pathways to Digital Information* (Los Angeles: Getty Research Institute, 1998). Also available in Spanish. Version 2.0 available only on the World Wide Web at <http://getty.edu/research/institute/standards/>.

3. Of particular interest is the FRBR (Functional Requirements for Bibliographic Records) model, which addresses the problem of linking hierarchic metadata records by allowing FRBR records to contain information on "works" and related "expressions," "manifestations," and "items," so that it is not necessary to recatalogue each instance. More information is available on the World Wide Web at <http://www.ifla.org>.

4. *Handbook of Standards: Documenting African Collections,* AFRICOM, 1996. Available on the World Wide Web in English and French versions at <http://icom.museum/afridoc/>. An Arabic version is under development, under the auspices of the ICOM Regional Organization for the Arab Countries.

5. Tim Berners-Lee, James Hendler, and Ora Lassila, "The Semantic Web," *Scientific American* 284, no. 5 (May 2001): 34–43.

6. For an extended discussion of these perils, see Howard Besser, "Digital Longevity," in Maxine K. Sitts, ed., *Handbook for Digital Projects: A Management Tool for Preservation and Access* (Andover, MA: Northeast Document Conservation Center, 2000): 155–66. Also available on the World Wide Web at <http://www.nedcc.org/digital/ix.htm>.

7. Oya Y. Rieger, "Project to Programs: Developing a Digital Preservation Policy," in Anne R. Kenney and Oya Y. Rieger, eds., *Moving Theory into Practice: Digital Imaging for Libraries and Archives* (Mountain View, CA: Research Libraries Group, 2000).

8. Additional information on the Rosetta Project is available on the World Wide Web at <http://www.rosettaproject.org>.

9. Additional information on OAIS is available from the NASA/Science Office of Standards and Technology (NOST) on the World Wide Web at <http://ssdoo.gsfc.nasa.gov/nost/isoas/>.

Glossary

Note: Boldface terms within entries are also defined in the glossary. In some cases, separate terms (e.g., **RGB** and **color model**) that are grouped consecutively (**RGB color model**) in the main text and glossary may appear to be one term.

AAT (Art & Architecture Thesaurus)
A **controlled vocabulary** maintained by the Getty Research Institute that identifies and organizes art and architecture terminology.

access file (or access image)
A file derived from a **master file** that is used to make a **digital** collection item accessible without hazarding the master. Typically compressed to reduce **storage** requirements and speed **online** delivery.

access points
A **database** field or **metadata** category designed to be searchable and retrievable by an end-user. Also used to denote a place where wireless network access is available.

ACL (Access Control List)
A way to limit access to **networks** to authorized users by using a router to forward or block requests from users based on a given protocol or criteria, such as **IP address**.

adaptive palette
A reduced **palette** of colors chosen to give the best possible reproduction of an image when it is displayed in a limited or "palettized" color environment, such as an 8-bit (256-color) display, or within a 256-color image **format**, such as **GIF**.

AFRICOM (International Council of African Museums)
Body that originated as a program of the International Council of Museums (ICOM) that has developed a **metadata standard** designed to promote the standardization of museum collection inventories in Africa.

algorithm
A set of steps in a specific order, such as the instructions in a computer program. Different image **compression** schemes employ different algorithms; for instance, the **JPEG** algorithm processes images as 8 x 8 image-blocks and applies cosine transformations to each block, while the **JPEG2000** algorithm applies wavelet transformations to the image as a whole.

analog
Any continually fluctuating or changing process, or any mechanism in which data is represented by continuously variable quantities. Analog images are **continuous tone**—the range of colors or shades of gray that they can include are virtually unlimited, and therefore their colors graduate smoothly. Because data in analog form can theoretically be represented by an infinite number of values, it may be difficult to differentiate between accurate reproduction and **noise**; thus, analog technology does not facilitate the accurate creation of copies, and analog reproduction may be of lower quality than **digital** reproduction.

annotation
Commentary added to a media object, generally providing explanatory information or editorial notes regarding the media file. Annotations are a form of **metadata**.

ANSI (American National Standards Institute)
U.S.-based body that does not directly develop **standards** but coordinates and administers voluntary consensus standardization initiatives.

archival master
The raw, original image captured by the scanning process and/or an image created and managed so as to optimize longevity and future usefulness. File naming, file formatting, **color space** selection, **capture resolution**, and similar specifications should be based on documented **standards**. Archival masters may be used as the source for **access images**, or these may be created from **derivative masters**. *See* **digital preservation**.

artifact
An error introduced into an image during capture or digitization, formatting, **compression**, or other transformation processes. Most commonly used to refer to the perceptible degradation of an image after a **lossy compression** schema has been used.

ASP (Active Server Page™)
One of several methods of dynamically generating **Web** pages in response to user input that may be used to gather information from remote **databases**. Utilizes "ActiveX" scripts. A Microsoft specification that may require third-party software to run on non-Windows platforms. ASP may also indicate an Application Service Provider. *See* **CGI**, **JSP**, **PHP**.

authentication

A human or machine process that verifies that an individual, computer, or information object is who or what s/he or it purports to be. Used in allowing access to secure systems.

authenticity

Refers to the trustworthiness of a **digital** entity, to its being what it professes to be, as regards its identity, origin, history, authorship, **integrity**, and/or the accuracy with which it documents an original work. The degree to which authenticity can be ascertained or guaranteed is likely to be determined by the quality of custody or management an entity enjoys over its life cycle.

authority (or **authority file)**

A file or set of terms extrinsic to records describing objects or documents. A more efficient way of recording information, which need be recorded only once and may then be linked to all appropriate records.

bandwidth

Denotes the capacity of a communications channel, such as an **Internet** link. Determines how fast data can flow over the channel. *See* **bit rate**.

batch processing

The automated application of a given process, such as **compression**, to multiple files.

bit

The smallest unit of computer data, denoted by a single binary value, either 0 or 1. Eight bits make up one **byte** in most computer systems.

bit depth

Also known as **sample depth** or **color depth**. The number of bits used to describe the color value of each **pixel** in an image, which in turn dictates the number of colors available to a given media file, monitor, or other device. An 8-bit image has 256 possible colors. A 24-bit image has approximately 16 million. *See* **dynamic range**.

bitmap (or **bitmapped image**, **raster image)**

An image made up of a given number of **pixels**, each with a specific color value, laid out in a grid. Ideal for reproducing photographic representations, because a sufficient quality and quantity of pixels can give the appearance of a **continuous tone** image. **Resizing** will affect apparent image quality. For instance, enlarging an image involves enlarging each pixel, which entails a reduction in **resolution**. *See* **vector graphic**.

bit rate

The number of **bits** that pass a given point in a **network** in a given amount of time, generally measured in kilobits or megabits per second (Kbps or Mbps). The bit rate is a measure of **bandwidth** and may also be referred to as the data transfer rate.

Boolean

A system of logical thought developed by George Boole (1815–1864) and adopted for use with binary values of computer operations. In Boolean searching, terms such as AND, OR, and NOT are used as operators to combine or exclude search terms.

born digital

Creations originally generated in **digital** form rather than copies or surrogates of **analog** originals, and which exist entirely in a digital environment. Examples include software, **Web** pages, hypertext fiction, and digital art.

broadband

High-speed data transmission or a transmission medium in which a wide range or band of frequencies is available to transmit data, allowing more information to be transmitted in a given time frame. As of this writing, broadband is sometimes defined as services that offer **bit rates** of 1.544 megabits per second (Mbps) and above. May also be referred to as wideband. Digital Subscriber Lines (DSLs) and cable modems allow broadband transmission. *See* **bandwidth**.

browser

See **Web browser**.

browser-safe palette

A **palette** of 216 colors whose appearance is predictable in all **browsers** and operating systems. Developed for 256-color displays—the remaining 40 colors are rendered differently by Macintosh and IBM-compatible or **Wintel** operating systems. Still used in **Web** design.

BSI (British Standards Institution)

Body that coordinates and publishes British, European, and international best practice recommendations and **standards**.

byte

In most computer systems, a unit of data that is eight binary digits or **bits** long. Generally used to represent a character such as a letter or number but may also hold a string of bits needed in some larger unit, such as the stream of bits that make up a visual image.

CAD (Computer-Aided Design)

Software used in architecture, archaeology, design, and other fields to create precision drawings, models, and technical illustrations in two or three dimensions. *See* **born digital**, **vector graphic**.

calibration

The comparison of the specifications of **image-capture**, processing, or display devices to a known **standard** to determine, and perhaps correct, any deviation or error. *See* **color management**.

capture resolution

The number of **samples** per inch (spi) that a **scanner** or **digital camera** is capable of capturing, or the number of samples per inch captured when a particular image is **digitized**.

cataloguing

The process of creating and arranging records that describe materials so as to facilitate identification, search and retrieval, acquisitions, circulation, **preservation**, rights, evaluation, and collocation. A record generally consists of a description; headings for topics, persons, places, etc.; an identification number; and links to related resources, such as **authority** records. Differs from a simple listing by the imposition of **controlled vocabularies** and by mechanisms allowing users to draw relationships between various entities.

CBIR (Content-Based Information Retrieval)

Technology that is able to retrieve images on the basis of machine-recognizable visual criteria. Such **indexing** is able to recognize and retrieve images by criteria such as color, iconic shape, or by the position of elements within the image frame.

CCD (Charge-Coupled Device)

Light-sensitive integrated circuits employed in **image capture** by **scanners** and **digital cameras**. CCDs capture image data as **pixels** with a numerical value that can be converted into an electrical charge, the intensity of which is related to a particular color.

CCITT

The former Comité Consultatif Internationale de Télégraphique et Téléphonique, now the **ITU**, that develops communications **standards**, including a group of related **lossless compression** schemas for black-and-white images used in fax transmission and supported by the PDF and PostScript language file formats.

CD-ROM (Compact Disk, Read-Only Memory)

A type of write-once, read-many (WORM) disk used to store and distribute large amounts of **digital** data on low-cost, optically recorded media. CD-ROMs profess to have much longer **storage** life ratings than magnetic media such as tape or hard disks, though there have been a few notable instances of failure in less than five years. Gold-reflective-layer CDs are most recommended for long-term storage. A standard CD-ROM stores approximately 650 megabytes of data. *See* **DVD-ROM**.

CDWA (Categories for the Description of Works of Art)

A conceptual framework for describing and accessing information about artworks and surrogates, maintained by the Getty Research Institute. The Visual Resources Association (VRA) Data Standards Committee expanded upon certain portions of the CDWA to formulate the **VRA Core Categories**.

CGI (Common Gateway Interface)

Part of the **Web**'s Hypertext Transfer Protocol (**HTTP**). A platform-independent method of dynamically generating Web pages in response to user input that may be used to gather information from remote **databases**. *See* **ASP**, **JSP**, **PHP**.

channels

The separate color components used by various **color models**. By default, **RGB** images have three channels: red, green, and blue; **CMYK** images have four: cyan, magenta, yellow, and black. Extra or "alpha" channels can be added to describe, for example, levels of transparency, or be used as masks that allow or restrict the output of color. Color creation occurs when the channels are combined before being sent to an output device such as a screen or printer.

checksum

A simple count of the total number of **bits** in a file or transmission unit that may be used to assess data **integrity** or detect error. In **digital preservation** management, checksums can be used to ascertain whether the number of bits in a file has changed over time.

CIDOC (International Committee for Documentation)

A committee of the International Council of Museums (ICOM) involved in developing **documentation standards**, such as the **CIDOC Information Categories** and **CRM**. *See* **AFRICOM**.

CIDOC Information Categories

A **metadata standard** intended to describe museum collection objects developed by the International Committee for Documentation.

CIE (Commission Internationale de l'Eclairage)

Organization that has developed a number of device-independent **color models** collectively called CIE color, including CIE XYZ, CIE LAB, and CIE LUV, that specify color based on human perception and are used as the basis for **color management** systems. *See* **CMS**, **color profile**.

client

See **client/server**.

client/server

Refers to a system architecture that divides functions between two or more computers, or two or more programs, so that one program, the client, makes a service request from another program, the server, which fulfills the request. This architecture is seen in **networks** where a client program in one computer (such as a **Web browser**) forwards a request to a server program in another (possibly distantly located) computer, which returns information to the client.

CMS (Color Management System)

A system designed to ensure the most accurate reproduction of color across multiple input, output, and display devices, and through the life cycle of an image. Each device in a color workflow will have inherent biases that cause it to interpret **digital** color values differently, and no device can properly reproduce the entire range of visible colors. Modern color management systems employ **ICC color profiles** to describe the color reproduction capabilities (and limitations) of individual devices. These are mapped to a device-independent **CIE**-based **color space**, facilitating conversion to matching color output across multiple devices and systems, within the practical limits of the devices. CMS may also refer to Content or Collection Management Systems.

CMYK (Cyan, Magenta, Yellow, Black)

Often referred to as four-color process, CMYK is a subtractive **color model**, using a mix of cyan, magenta, yellow, and black inks to reproduce a range of colors. CMYK is the most basic color process used in print.

codec

A *c*ompression/*dec*ompression (sometimes *co*der/*dec*oder) **algorithm** or scheme that reduces the volume of **bits** necessary to store a data object such as an image file (**compression**) but that allows the reconstruction of the compressed data into a usable format for display, processing, etc. (**decompression**). There are many different codecs, and they are often used to minimize file transfer time in order to optimize images or data for **Web** use.

color chart

A **calibration** target consisting of a matrix or spectrum of colors set to a known **standard**. Color charts can provide reference points to ensure accuracy of color capture and to calibrate output devices. May also be referred to as a color patch. *See* **gray scale**.

color correction

The process of adjusting color values in an image to match the original or a reference image in order to compensate for the normal shifts and biases incurred during digitization and subsequent image processing. *See* **CMS**.

color depth

See **bit depth**.

color management

The practice of **calibrating** all devices in the **image capture**, processing, and output chain to ensure the fidelity of **digital** image files to the objects they represent. Color management can be achieved by manually calibrating devices using **color charts** and **ICC** profiles followed by regular reassessment, or by means of **CMS** software.

color model

An attempt to describe color in a mathematical, predictable, and reproducible way. Usually posits a small core set of colors from which all possible colors can be derived. The **RGB** model assumes that all colors are formed by a given combination of red, green, and blue; the **CMYK** model assumes that all colors are produced by a combination of cyan, magenta, yellow, and black. Both models fall short of describing the whole gamut of visible color. Also known as color system or **color space**. *See* **CIE**, **gray scale**, **HSB/HLS**.

color profile

A file containing data that describes a particular device's **color space** in relationship to an ideal, theoretical, device-independent color space (the **CIE** XYZ color space). Profiles facilitate the conversion of images from one color space to another and form the foundation of color management systems (**CMS**). Most profiles are generated using **ICC standards**.

color space

A three-dimensional geometric representation of the colors that can be discerned and/or created by a particular **color model** (the two expressions may be used interchangeably). May also refer to the range of possible colors that can be produced by a particular output device—such as a monitor, color printer, photographic film, or print-

ing press—or the color description abilities of a particular file **format**; may also be known as a color gamut. Generally described by a **color profile**.

compression

The reduction of file size to facilitate transmission or **storage** via any of various **algorithms**. Often required by image files, which are significantly larger than text files. Some algorithms allow the original data to be reconstituted upon decoding or decompression (**lossless compression**), while others discard data permanently (**lossy compression**), which allows a greater reduction in file size. Regardless of the type of compression used, the higher the level of compression, the more noticeable will be the loss in image detail. *See* **codec**.

continuous tone

Refers to images that have an unlimited (or nearly so) range of colors or shades of gray, and which show smooth gradation between shades. **Digital** image reproduction is always confined to limited **palettes**, albeit palettes that may have millions of different colors, while the ability of **bitmapped images** to mimic continuous tone is limited by their **bit depth** and **resolution**. *See* **analog**, **HDRI**, **pixel**.

controlled vocabulary

An established list of terms from which an indexer or cataloguer may select when assigning descriptors or subject headings to a record. *See* **authority**, **cataloguing**, **indexing**, **thesaurus**.

CRM (Conceptual Reference Model)

A **metadata standard**, developed by **CIDOC**, intended to provide a common and extensible semantic framework to which any cultural heritage information can be mapped.

cross-platform

Applications or data that can be used over more than one computer platform or operating system. Facilitated by the adoption of **open standards**.

crosswalk

A chart or table that represents the semantic mapping of fields or data elements in one **metadata standard** to fields or data elements in another standard that has a similar function or meaning. Crosswalks allow semantic **interoperability**. They enable heterogeneous **databases** to be searched simultaneously with a single query as if they were a single database, and facilitate accurate conversion from one metadata standard to another. Also known as field mapping or metadata mapping. *See* **RDF**.

DAM (Digital Asset Management)

A system that enables the management of **digital objects**, such as image files, from **ingest** to archiving and supports continued retrieval. Off-the-shelf DAM software may offer templates and other devices or strategies to facilitate ingest, **metadata** capture, and searching. May also be called media asset management (**MAM**).

database

A structured collection of data. The most common data-structuring model is "relational," where data is organized in related or linked tables that can be accessed or reassembled in many different ways. Object-oriented databases are also common.

data dictionary

An exhaustive list and description of data elements. May be contrasted with a **metadata schema**, which is a selection of data elements and rules for their use geared to a particular purpose.

DCMI (Dublin Core Metadata Initiative)

Body engaged in the development of **interoperable online metadata standards** to support a broad range of purposes. *See* **Dublin Core**.

decompression

See **compression**.

derivative file

A file derived or created from another file, rather than created during an original digitization process. Differs from a copy insofar as the derivative file may be altered in some way from the original.

derivative master

A high-quality "working" image file that is derived from an **archival master** image file, then subjected to some form of processing, such as **color correction**. May also be known as a submaster. Typically used as the source from which smaller, lower-quality **access images** intended for transmission over the **Internet** are derived, while archival masters are kept reserved.

digital

Electronic technology that generates, stores, and transmits data in terms of a limited number of discrete states, most commonly as binary data in which two possible states, positive or nonpositive, are represented by 1 or 0, respectively. Because there are only two

possible values, the accuracy of binary digital data at any given point is relatively easy to test, and therefore digital technology facilitates the creation of accurate copies. *See* **digital image**.

digital archaeology
The process of reclaiming **digital** information that has been damaged or is unusable due to **format** or media obsolescence. May employ any number of techniques. *See* **digital preservation**.

digital asset
See **digital object**.

digital camera
An **image-capture** device that directly captures **digital** images without the use of film or other **analog** processing. Digital cameras typically employ **CCD** photosensors and output **bitmapped images**. *See* **drum scanner**, **flatbed scanner**, **transparency scanner**.

digital certificate
An electronic identifier issued by a certification agency that establishes a user's credentials. Contains the registrant's name, a serial number, certificate expiration information, a copy of the certificate holder's **public key**, and the **digital signature** of the certificate-issuing authority. A recipient can verify that a certificate is real by comparing the public key received with that held in a registry for the certificate holder.

digital image
An image described as a set of **digital** data, such as **pixels** or vectors. Digital images may be **digitized** from **analog** sources such as photographs or may be generated directly within computer applications. If they are not **born digital**, **bitmapped images** consist of pixels whose values are derived from **samples** taken from analog originals, and may use thousands or millions of discrete gradations of color to approximate analog **continuous tone** images. *See* **bitmap**, **vector graphic**.

digital object
Data (the content or "essence" of a **digital** file) and the **metadata** describing it, regarded together as a single entity. Also known as a digital asset, an information object, or an information package. May also refer to **born digital** objects.

digital preservation
The specific problems and methods of preserving **digital**, as opposed to **analog**, assets because of their vulnerability to **format** obsolescence and media decay. Various strategies have been developed to respond to this, including **documentation**, the gathering of preservation **metadata**, the use of **open standards**, **redundant storage**, **refreshing**, **migration**, **emulation**, **technology preservation**, **re-creation**, and **digital archaeology**.

digital signature
A form of electronic **authentication** of a **digital** document. Digital signatures are created and verified using **public-key encryption** and serve to tie the document being signed to the signer.

digitizing
The process of deriving **digital objects** from **analog** originals by converting their **sampled** values to binary code. Also known as analog-to-digital conversion and **image capture**.

DIN (Deutsches Institut für Normung)
National **standards** body that represents German interests at European and international levels.

diodes
Light-sensitive electronic components used in **image capture**. They function as one-way valves that sense the presence or absence of light and create a **digital** signal that the computer converts into **pixel** values.

directory (or directory service)
A listing of users and user passwords linked to information about which **network** resources each user may access. Examples include LDAP, Active Directory, and NDS.

DMZ (DeMilitarized Zone)
In the computer **network** context, a computer host or small network that provides an intermediate space between an **extranet** and an **intranet** and so prevents direct access to internal network resources by unauthorized users. Typically secured by two or more **firewalls**.

documentation
Textual information that describes a work of art or image, recording its physical characteristics and placing it in context. May be regarded as one of the most basic **preservation** strategies for **digital** files. *See* **cataloguing**, **digital preservation**, **metadata**.

domain name

An address that identifies an **Internet** or other **network** site and acts as a mnemonic alias for an **IP address**. Domain names consist of at least two parts: the top-level domain, which specifies host addresses at a national or broad sectoral level (e.g., ".edu" for the U.S. educational sector); and the subdomain, which is registered to a specific organization or individual within that domain (e.g., "getty" is registered to the Getty Trust within the .edu domain).

dot pitch

The distance between phosphor "dots," the smallest visual components of an electronic display device. Dot pitch is measured in millimeters (mm) and indicates how sharp a displayed image can be: the smaller the dot pitch, the sharper the image. Users working with images will usually want 0.28mm or finer dot pitch. *See* **monitor resolution**.

DRM (Digital Rights Management)

Server software that may use a number of techniques to control distribution of (usually commercial) content over the **Web**.

drum scanner

A high-quality **image-capture** device that uses **PMT** technology. The original is secured to the drum surface with mounting tape and oil, and the drum then revolves at several hundred revolutions per minute around the scanning mechanism, which in turn moves along the drum, executing a tight spiral scan of its entire surface. **Capture resolution** is determined by the number of **samples** per revolution and the speed at which the scanning sensor moves. Allows higher **resolution**, wider **dynamic range**, and greater **bit depth** than **flatbed scanners**. *See* **digital camera**, **transparency scanner**.

DTD (Document Type Definition)

A formal specification of the structural elements and markup definitions to be used in encoding **SGML**-compliant documents. Examples of DTDs include **EAD** and **HTML**. **XML** is a flexible format that allows for the creation of various DTDs to fit particular purposes. *See* **XSD**.

Dublin Core

A minimal set of **metadata** elements that creators or cataloguers can assign to information resources, regardless of the form of those resources, which can then be used for **network** resource discovery, especially on the **World Wide Web**.

DVD-ROM (Digital Versatile Disk, Read-Only Memory)

A type of write-once, read-many (WORM) disk used to store and distribute large amounts of **digital** data on low-cost, optically recorded media. The DVD-ROM is a newer, and more densely packed, form of **storage** than the **CD-ROM**, and therefore not as well established or, possibly, as reliable for archival purposes. A double-sided, dual layer disk can store up to seventeen gigabytes of data, but the more densely packed the data is, the more vulnerable it is likely to be to degradation. Gold-reflective-layer DVDs are recommended for long-term storage.

dynamic range

The ratio between the brightest and darkest parts of an image, or the potential range of color and luminosity values that can be represented within an image or produced or recognized by a particular output or capture device. *See* **bit depth**, **color space**, **HDRI**, **palette**.

EAD (Encoded Archival Description)

An **SGML DTD** that represents a highly structured way to create "finding aids" for groupings of archival or manuscript materials, making them accessible to researchers by listing the constituent items and their locations.

effective resolution

May be used misleadingly as a substitute term for **interpolated resolution**. Generally refers to "real" **resolution** under given circumstances. Examples include: the possible **capture resolution** of a **digital camera**, as constrained by the area actually exposed by the camera lens; the number of **pixels** per inch of an image, as affected by **resizing** that image; or the **capture resolution** of a scan taken from an intermediary such as a photograph, when mapped to the scale of the original object.

emulation

A **digital preservation** strategy that uses current software to simulate original or obsolete computer environments. May either restore full functionality to archival data or provide a simple viewing mechanism. *See* **digital archaeology**.

encryption

A way of transforming data into "cyphertext" through the use of computer **algorithms** that rearrange the data **bits** in **digital** signals in order to prevent them from being read by unauthorized users. May also be used for user and document **authentication**, because only designated users or recipients are given the capability to decrypt or decipher encrypted materials.

extranet

A private **network** that allows an organization to share information, such as parts of their **intranet**, with external users such as vendors or clients over the **Internet**. Extranet systems require security such as **firewall** server management and a means of user **authentication**.

failover

A backup operational mode in which functions are assumed by secondary system components if the primary component becomes unavailable. Used to make **storage** and other systems more fault-tolerant.

film scanner

See **transparency scanner**.

firewall

Software, or software and hardware, that serves as a gateway to block certain types of **network** traffic, typically used to protect **intranets** from access through **extranets**. Most firewalls work by filtering packets and routing requests based upon **IP addresses**. Others use secure log-on procedures and **authentication** certificates.

flatbed scanner

An **image-capture** device resembling a photocopy machine. The object to be scanned is placed facedown on a glass plate, and a **CCD** array that passes beneath the glass captures an image of the object by **sampling** it at regular intervals. *See* **digital camera**, **drum scanner**, **transparency scanner**.

format

A specification for organizing data. **Digital images** (and their associated **metadata**) may be presented in a number of formats depending on **compression** schemes, intended use, or **interoperability** requirements. Some image formats are broadly decipherable, while others may only be accessible to certain application programs. *See* **GIF**, **JPEG**, **JPEG2000**, **PNG**, **TIFF**.

FTP (File Transfer Protocol)

A method of moving, transferring, or copying files between computers over the **Internet** via **TCP/IP**, rather than simply viewing them over the **World Wide Web** via **HTTP** with the aid of a **Web browser**.

GIF (Graphics Interchange Format)

A widespread **digital image** file **format** introduced by CompuServe, which supports basic animation capabilities and uses **LZW compression**. Can provide only 8-bit color (256 colors) and employs an **adaptive palette** for each image, making GIF undesirable for most **continuous tone** images, such as photographs, though useful for limited-**palette**, monochrome, or **thumbnail** images.

gray scale

The range of shades of gray that **scanners** and monitors can recognize and reproduce, or that is contained within a black-and-white image. May also be used as an alternative term for black and white (a black-and-white image that is digitized has been "grayscaled"). Or, a calibration target showing a standardized continuum of shades between black and white used to determine **image-capture** device specifications. *See* **color chart**.

hacker

A term used to describe a person who endeavors to break into a computer system for some purpose by circumventing security protocols. Sometimes used to describe a particularly talented programmer.

HDRI (High-Dynamic Range Image/Imaging)

An image or image processing device that utilizes a greater **dynamic range** or higher **bit depth** (generally 48-bit or higher) than can be shown on a typical display device, or that can be captured by a single exposure with an ordinary camera. The "extra" **bits** are used to record light and shade (luminance) more accurately.

header

In a computer file, a field or series of fields that precedes the main file content and contains **metadata** describing, for instance, the **compression** or size of an image. Some such fields are automatically filled, but additional metadata may be embedded into the header part of files of certain **formats** for description and management purposes.

HSB/HLS (Hue, Saturation, Brightness/Hue, Lightness, Saturation)

Two variations of a device-independent **color model** that closely matches the way the human eye perceives color. Often used in desktop graphics programs.

HTML (HyperText Markup Language)

An **SGML**-based markup language used to create documents for **World Wide Web** applications. Predominately concerned with specifying the design and appearance of content, rather than the representation of document structure and data elements. *See* **XML**.

HTTP (HyperText Transfer Protocol)

Application protocol specifying the rules for exchanging **HTML** documents and media files over the **World Wide Web**.

ICC (International Color Consortium)

Body promoting the standardization of open, vendor-neutral, **cross-platform** color management system (**CMS**) architecture and components. Developer of the ICC **color profile** specification.

ICONCLASS

A system of letters and numbers used to classify the iconography of works of art, developed in the Netherlands.

IEC (International Electrotechnical Commission)

Organization that prepares and publishes international **standards** that may serve as a basis for national standardization for all electrical, electronic, and related technologies.

IEEE (Institute of Electrical and Electronics Engineers)

Body that promotes development and **standards** in the electronic and information technologies and sciences.

image capture

See **digitizing**.

image resolution

The number of **pixels**, in both height and width, making up an image. Generally, the higher the number of pixels, the greater the image's clarity and definition. *See* **resolution**.

index

See **indexing**.

indexing

The process of making a list of terms and other data stored in a structured data file and used to enhance access and discovery. Indexing terms represent the most salient information necessary to retrieve a record or object; they are often taken from a **controlled vocabulary**. See **authority**, **cataloguing**, **thesaurus**.

ingest

The process of entering new assets into a management system. The contributor transmits an asset and its **metadata**, either bundled together as a single **digital object** or separately, to allow accurate retrieval and eventual reuse of the asset.

integration

Combining systems, applications, or sets of data so that they work together. In "seamless" integration, the distinctions or boundaries between systems are imperceptible to users.

integrity

A **digital** entity has integrity when it is whole and sound or when it is complete and uncorrupted in all its essential respects. *See* **authenticity**.

interface

Allows users to communicate with, or use, applications by entering or requesting data. Most are now graphical user interfaces (GUIs), in which functions are displayed graphically and can be activated using a cursor or similar pointing device rather than using older text-, keyboard-, or menu-driven controls. Hardware interfaces allow pieces of equipment to communicate or work together.

Internet

A global collection of computer **networks** that exchange information by the **TCP/IP** suite of networking protocols.

interoperability

The ability of different computer-based systems or applications to work together correctly, particularly in the correct interpretation of data semantics, or their ability to understand and, where appropriate, utilize each other's data. Applications and systems that adhere to known **standards** promote interoperability and remove reliance on a small group of suppliers.

interpolated resolution

The **resolution** at which a device is capable of capturing or generating an image using **interpolation** (i.e., using data that has no authentic relation to an original). *See* **optical resolution**.

interpolation

An estimation of a value within two known values. A means by which a device can exceed its **optical resolution** capacity by inserting new **pixels** in between those derived by **sampling** the original. Can improve apparent picture quality; however, interpolated images tend to look blurred when they are enlarged and use data that is inauthentic or not derived from the original.

intranet

A private **network** that is accessed via **TCP/IP** and other **Internet** protocols but uses a gateway to limit access, typically to local users recognized by **IP address**, domain, or by some other means of **authentication**.

IP (Intellectual Property)

Any intangible asset that is a product of human knowledge and ideas. Examples include patents, copyrights, trademarks, and software. IP may also denote "Internet Protocol."

IP (Internet Protocol)

The method by which data packages are delivered from computer to computer over the **Internet**. Once delivered, the Transmission Control Protocol **(TCP)** puts them into the correct order. IP may also denote "intellectual property."

IP address

Part of the Internet Protocol (**IP**). A hierarchical, numeric addressing system that can be used to identify each device sending or receiving information on a **network** with a 32-bit number.

ISO (International Organization for Standardization)

Body that promotes standardization. Many national **standards**-making bodies, such as **ANSI**, participate in, and contribute to, ISO standards making. The Joint Photographers Experts Group (**JPEG**) and the Motion Picture Experts Group (**MPEG**) are both bodies within the ISO.

ITU (International Telecommunications Union)

Organization with the United Nations System that coordinates telecom **networks** and services. The ITU-T division produces **standards** or recommendations for all areas of telecommunication.

JFIF (JPEG File Interchange Format)

A public domain iteration of the **JPEG** image-**compression** format.

JPEG (Joint Photographers Experts Group)

A body within the **ISO**. Also a widely adopted image **compression standard** developed by that body, which uses a **lossy-compression algorithm** able to significantly reduce image file size while maintaining reasonable image quality. Typically capable of compression ratios from 10:1 to 20:1.

JPEG2000

A file **format** that uses **wavelet compression** to allow both **lossy** and **lossless compression** and can provide **scalable** images from a single compressed file. Commercial implementations are becoming available, and **open-source** implementations are in development. A separate standard to **JPEG**, and generally able to provide reasonable image quality at higher compression ratios (some sources cite ratios of 2:1 with lossless compression and up to 200:1 with lossy compression).

JSP (Java Server Pages™)

One of several methods of dynamically generating **Web** pages in response to user input that may be used to gather information from remote **databases**. Platform-independent technology developed by Sun Microsystems that utilizes small programs called "servlets." *See* **ASP**, **CGI**, **PHP**.

LAN (Local Area Network)

A limited **network**, typically within a building or department and owned and operated by the user. May be connected to other networks, such as the **Internet**, via network points known as gateways. An ethernet is a high-**bandwidth** LAN specification used to network computers and other devices together in a cabled or wireless environment.

LCSH (Library of Congress Subject Headings)

A **controlled vocabulary** of terms commonly used to retrieve library materials.

lossless compression

Reduction in file size without loss of information, achieved by storing data more efficiently. A **bitmapped image** that has undergone lossless compression will be identical to the original uncompressed image when decompressed. The **GIF**, **TIFF**, **PNG**, and **JPEG2000** image **formats** allow lossless compression, which cannot shrink file size to the extent possible with **lossy compression**.

lossy compression

Reduction in file size that involves permanent loss of information. **Algorithms** selectively discard data in order to attain a greater size diminishment than is possible with **lossless compression**. Entails a decrease in quality, but this is often imperceptible (or nearly so) with image files, depending on the level and type of compression employed. The **JPEG** and **JPEG2000 formats** allow lossy compression.

LZW (Lempel-Ziv-Welch)

A **proprietary lossless-compression algorithm**.

machine-readable

Data presented in an electromagnetic form that a computer can access, such as data stored on disk or tape, and organized in such a way that given the correct program, a computer can process or execute instructions contained in the data, such as rendering an image.

MAM (Media Asset Management)

A system for handling media assets through processes such as **cataloguing**, controlling access, managing circulation, tracking rights and publication history, and ensuring **preservation**, or software designed to perform all or some of these tasks. May also be called digital asset management (**DAM**).

MAN (Metropolitan Area Network)

A **network** that connects users over a region larger than a **LAN** but smaller than a **WAN**. Can be used to denote the interconnection of several LANs but most often applies to the interconnection of networks in a city into a single, larger network.

MARC (MAchine-Readable Cataloguing)

A set of standardized **metadata** structures that facilitates cooperative **cataloguing** and data exchange in information systems. Developed to describe bibliographic materials but extended to describe nonbibliographic holdings.

master file (or master image)

A high-quality, uncompressed **digital** file, or the highest quality file available, from which other files, most commonly smaller, **compressed** files for **online** access, can be derived. Master images will have the greatest level of detail and color fidelity available. *See* **archival master, derivative master**.

metadata

Commonly defined as "structured data about data," or data captured in specific categories or elements. Metadata can include data associated with either an information system or a data object or set of objects for purposes of description, administration, **preservation**, the documentation of legal requirements, technical functionality, use and usage, and so forth. *See* **cataloguing**, **digital object**.

metadata schema

A set of rules for recording or encoding information that supports a specific **metadata** element set.

meta tag

An **HTML** tag that enables descriptive **metadata** to be embedded invisibly on **Web** pages, used by some **search engines** to establish relevance to search requests.

METS (Metadata Encoding and Transmission Standard)

A flexible **XML** format for **digital** library objects that provides a "**wrapper**" to hold together the various types of **metadata** that may be used to describe an asset or group of assets. Data and metadata may be embedded within a METS document, or the document may point to external resources. The format's generalized framework offers a syntax for the transfer of **digital objects** between repositories that may be used within the **OAIS** model.

middleware

A computer program that mediates between two existing, separate computer programs.

migration

Digital preservation strategy that involves transferring data from a **format** or **standard** that is in danger of becoming obsolete to a current format or standard. The most common example is the process of upgrading files to become compatible with a new version of software or operating system. May also be known as conversion or reformatting.

MIX (Metadata for Images in XML)

XML metadata schema developed by **NISO** and the Library of Congress, based on the *NISO Data Dictionary: Technical Metadata for Digital Still Images*.

MODS (Metadata Object Description Schema)

XML metadata schema developed by the Library of Congress and the **MARC** Standards Office designed to both transmit selected data from existing MARC 21 records and enable the creation of original resource description records

monitor resolution

May be used interchangeably with **screen resolution** or may indicate the maximum possible resolution of a computer monitor. Higher monitor resolution indicates that a monitor is capable of displaying finer and sharper detail, or smaller **pixels**. Monitor detail capacity can also be indicated by **dot pitch**.

MPEG (Motion Picture Experts Group)

A body within the **ISO** that has produced **standards** for the **compression**, **storage**, and **documentation** of multimedia and motion pictures, such as the **MPEG-7 standard** or the MPEG-21 Multimedia Framework.

MPEG-7 (Multimedia Content Description Interface)
A **metadata standard** that provides a set of standardized tools to describe multimedia content. Both human users and automatic systems that process audiovisual information are within its scope.

NAF (Name Authority File)
Authority file maintained by the Library of Congress that contains headings for names, uniform titles, and series.

NAS (Network-Attached Storage)
A system where a data **storage** device is attached to a **LAN** and assigned its own **IP address**, rather than being attached to the **server** offering data processing and management functionality, thus releasing the server from data delivery duties. May be incorporated into a **SAN** system. Affordable consumer NAS systems are entering the market as of this writing.

native-XML
Used to describe applications that are able to process **XML** data without transforming it to another **format**. For instance, native-XML **databases** allow XML documents to be stored, indexed, and retrieved in their original format, preserving their content, tags, attributes, entity references, and ordering. *See* **XML-enabled**.

nearline
Storage and retrieval system where assets are stored **offline**, such as on removable disks (hard drives, **CD-** or **DVD-ROM**s), but are available in a relatively short time frame if requested for **online** use or use over a **network**.

network
An arrangement of devices such as **servers**, computers, and printers joined by transmission paths by which programs make requests of one another. Local area networks (**LAN**), metropolitan area networks (**MAN**), wide area networks (**WAN**), and the **Internet** are all examples of networks.

network topology
A particular configuration used to connect devices on a **network**.

NISO (National Information Standards Organization)
Body that identifies, develops, maintains, and publishes technical **standards** to manage information in both traditional and new technologies.

noise
Unwanted data or imperfections in a file that are somehow developed in the course of scanning, processing, or data transfer.

OAI (Open Archives Initiative)
Body that develops and promotes **interoperability standards** that aim to facilitate the efficient dissemination of content, such as its **XML/Dublin Core**-based Protocol for Metadata Harvesting, which provides a mechanism for "harvesting" or gathering XML-formatted **metadata** from diverse repositories.

OAIS (Open Archival Information System)
The Reference Model for an Open Archival Information System provides a common conceptual framework for creating archival systems designed to aid the long-term **preservation** of, and access to, **digital** information. Often cited in concert with **METS**; a METS document could serve as a Submission Information Package (SIP), an Archival Information Package (AIP), or a Dissemination Information Package (DIP) within the OAIS model.

Object ID
Metadata schema that sets out the minimum information needed to protect or recover an object from theft and illicit traffic. Its purpose is to uniquely identify an object in order to establish ownership.

offline
Storage and retrieval system where assets are not immediately available for use, or not accessible through a **network** or computer, but stored on some independent media, such as a **CD-ROM**.

online
Storage and retrieval system where assets are immediately available for use or directly connected to a **network** or computer through fixed disk **storage**.

OPAC (Online Public Access Catalog)
Automated, computerized library catalogs made available to a wide range of users.

open architecture
A system design and framework that is well defined and uses **open standards** so that functionality can be added by third parties. This allows the original technology to benefit from industry-wide developments and allows users more flexibility in extending an application or building **interoperability** with other systems.

open source

A product or system whose workings or source code are exposed to the public and therefore to modification by anyone. Open source software is generally developed as a public collaboration and made freely available for use or modification as developers see fit, as opposed to **proprietary** products or systems. Open systems built to known **standards** promote **interoperability**.

open standards

Freely available structures, procedures, or tools for the uniform creation and description of data. Usually defined and perhaps maintained by a central body, but, unlike **proprietary standards**, users are not reliant on a private organization to license use and provide support.

optical resolution

The **resolution** at which a capture device, such as a **scanner** or **digital camera**, is capable of capturing **pixel** values based on actual **samples** taken from an original to construct an image. Optical resolution is the true measure of the capture capacity or quality of a scanner, as opposed to **interpolated resolution**.

output resolution

The **resolution** of an image based upon the dimensions, in **pixels** or units of length, as affected by the chosen output method, such as display on a monitor or printing on a page.

palette

The set of colors that appears in a particular **digital image**, or the set of available colors based on the **color space** being used by a particular output device.

password

A character sequence providing means of **authentication** for a user requesting access to a computer or application. A password is typically entered along with a user name or identifier that, when paired with the password, serves to uniquely identify a user and associate the user with a particular profile, or set of access privileges and rights.

peer-to-peer (P2P)

As distinct from **client/server** relationship, a peer-to-peer **network** connects computers or programs so that no party is dedicated to serve the other, and any is able to initiate a transaction.

PHP (Hypertext Preprocessor)

One of several methods of dynamically generating **Web** pages in response to user input that may be used to gather information from remote **databases**. Utilizes **open source** script language. *See* **ASP**, **CGI**, **JSP**.

pixel

From *pic*ture *el*ement. The smallest programmed unit of a **bitmapped image**, similar to grain in a photograph or a dot in a halftone print. Pixel size, frequency, and color determine the accuracy with which photographic images can be represented. The greater a pixel's **bit depth**, the greater the number of different shades or colors it can represent. The larger or fewer the pixels within an image, the more likely "pixelation"—where individual pixels become apparent and break the illusion of **continuous tone**—is to occur. *See* **resolution**, **sample**.

plug-in

An easily installed, usually downloadable program used by a **Web browser** to enable the use of certain media or the execution of specialized **Web** functionality. A media player, where audio or video encoding requires a particular player to decode and run media files, is an example of a plug-in.

PMT (PhotoMultiplier Tube)

An amplifying vacuum tube used in **drum scanners**. PMT technology is highly sensitive to differences in light intensity. It takes in light reflected from reflective originals or through transparent originals, converts it to an electrical signal, and amplifies the signal to measurable levels that can then be assigned **digital** color values.

PNG (Portable Network Graphics)

A patent-free file **format** for **lossless compression** of images that provides some additional features that improve the ability to control image appearance over the **GIF** format.

preservation

See **digital preservation**.

printer resolution

The maximum density of dots per inch that a printing device is capable of producing, or the density of dots per inch used in a particular printing.

proprietary

A technology or product that is owned exclusively by a single commercial entity that keeps knowledge of its inner workings secret. Some proprietary products can only function when used with other products of the same ownership. The limitations of proprietary technology are fueling moves toward **open standards**.

public-key encryption

A security measure used in **digital signatures** wherein a value provided by a designated authority is combined with a private key value and used to **encrypt** transmitted data.

quality control

Techniques ensuring that accuracy and high quality are maintained through various stages of a process. For example, quality control during **image capture** might include comparing the scanned image to the original and then adjusting colors or orientation.

RAID (Redundant Array of Independent Disks)

Storage device comprised of systems of multiple hard disks holding the same information. Intended to increase performance and reliability in serving and storing data. There are various RAID configurations, each suited to different needs relating to demand or traffic, user needs such as read-only or read/write, and fault-tolerance requirements.

raster image

See **bitmap**.

RDF (Resource Description Framework)

A foundation for processing **metadata** that complements **XML** and includes a standard syntax for describing and querying data. Yet to be generally adopted as of this writing. A component of the proposed **Semantic Web**. *See* **crosswalk**.

re-creation

A **digital preservation** concept postulating that if the delivery and content of **born digital** work such as multimedia or installation art could be adequately documented in a way that was independent of its native medium or platform, it would be possible to re-create it using a future medium or platform.

redundant storage

A **digital preservation** strategy whereby two or more copies of **digital** content are made on the same or different media and stored in different locations under archival environmental conditions. For example, one set of media may be stored offsite, or two institutions may agree to store one another's redundant copies.

refreshing

A **digital preservation** strategy that protects against the possible degradation of **digital** content due to **storage** media decay by copying digital information held on a particular storage medium to a new medium, of the same or different type, while keeping the digital information itself in the same **format**.

refresh rate

The number of times that a screen display is refreshed or repainted per second, expressed in hertz. The refresh rate for each display depends on the system **video card**. Rates of below 70 Hz can cause image flickering and eyestrain, and, as such, rates of 75 Hz to 85 Hz are recommended.

resampling

May be used interchangeably with **resizing**. Alternatively, refers to changing the number and values of **pixels** in an image, technically by creating a new, empty **bitmap** of the desired dimensions and using the original image pixels as the basis from which to work out the values for each new pixel using various **algorithms**. Resampling generally involves **interpolation** and should be used cautiously. *See* **compression**.

resizing

May be used interchangeably with **resampling**. Alternatively, it refers to changing the physical dimensions of an image file without changing its pixel dimensions (for example, by changing the parameters for default print size). This would result in the **output resolution** of an image being set to a particular value but in no information (no pixels) being gained or lost.

resolution

A relative, rather than an absolute, value, usually expressed as the density of elements, such as **pixels**, within a specific distance, most commonly an inch. *See* **capture resolution, effective resolution, image resolution, interpolated resolution, monitor resolution, optical resolution, output resolution, printer resolution, screen resolution**.

resource sharing

The ability to federate collections of **digital** assets, or simply the **metadata** describing those assets, into larger resources where the costs of management are shared. Or, the ability to use assets and/or metadata outside the system or institution in which they originated. Examples include the OCLC (Online Computer Library Center, Inc.) Digital Archive; AMICO (the Art Museum Image Consortium), where contributors transmit catalog records, digital files, and metadata records for museum objects to a central repository; RLG (Research Libraries Group) Cultural Materials; and ARTstor.

RGB (Red, Green, Blue)

An additive **color model** or system for representing the color spectrum using combinations of red, green, and blue. Used in video display devices, and is the standard color system for most **digital** imaging devices and applications.

rights management

The description and identification of intellectual property (**IP**) and the rights and restrictions relating to it, including the conditions of use. May become very complicated where dealing with originals and various **digital** surrogates, where each instance of a work may have different restrictions placed upon it.

RLG Preservation Metadata Elements

A **metadata** element set intended to capture the minimum information needed to manage and maintain **digital** files over the long term. It captures technical rather than descriptive information and may be combined with any descriptive element set to describe an image file.

sample

A **digital** value derived from measuring a discrete part of an **analog** original. See **sampling**.

sample depth

See **bit depth, dynamic range**.

sampling

The mechanism by which **analog** signals or objects are **digitized**. Sampling involves dividing an analog whole into regularly spaced, smaller discrete components, measuring the values of each such component, and converting these measurements to binary code. Provided enough **samples** are taken, the readings create the illusion of a continuous (i.e., **analog**) signal or object when decoded.

SAN (Storage Area Network)

A sophisticated **online storage** system where a high-speed special-purpose subnetwork of shared storage devices is accessible from any **server** in the **LAN** or **WAN network** of which the SAN is a part. In this system, data is readily accessible, but because it is stored separately from the server, server power and network capacity are released for other purposes. See **NAS**.

scalable

A scalable system is one whose size can be adjusted to meet ongoing requirements or where each part of a system is flexible enough to accommodate growth or reduction in another part. **Open-source** systems are more likely to be scalable over time, as they allow a greater number of alternative responses to change.

scanner

A device that captures images from **analog** sources for computer editing and display. See **digital camera, drum scanner, flatbed scanner, transparency scanner**.

screen resolution

Sometimes used interchangeably with **monitor resolution**. Otherwise refers to the number of **pixels** shown on a computer monitor screen. Screen or display resolution is variable and may be set to a number of default settings, such as 800 x 600 or 1024 x 768.

search engine

A set of programs accessed through the use of a **Web browser** that executes searches on the **Internet**. There are various search engines, but most include a program that goes out and reads searchable **Web** site pages, a program that creates an **index** or catalog of searched pages, and a program that receives the search request and returns results, usually in the form of a ranked list chosen from the index. May be confined to searching a particular site or set of sites.

Semantic Web

An idea or proposal to enhance the "intelligence" of the **Web** set forth by its inventor, Tim Berners-Lee. Web content authors would describe, catalogue, or **index** sites to improve the ability of future **search engines** to recognize context and therefore return more relevant results to Web users. See **RDF, XML**.

server

A computer program that provides services to other computer programs by responding to requests and supplying or accepting data. See **client/server, storage**.

SGML (Standard Generalized Markup Language)

ISO standard ISO/IEC 8879:1986, first used by the publishing industry, for defining, specifying, and creating **digital** documents that can be delivered, displayed, linked, and manipulated in a system-independent manner. *See* **DTD**, **HTML**, **XML**.

SPECTRUM

A broad range of data elements associated with transactions for museum objects developed by the UK-based mda.

SPIFF (Still Picture Interchange File Format)

A **format** intended to replace the ubiquitous, as of this writing, **JFIF** as the format for images using the **JPEG compression algorithm**. It offers additional **color spaces** as well as expanded functionality.

sRGB

A single, default **RGB** color space for display devices, codeveloped by Microsoft and Hewlett-Packard, intended to standardize the many different RGB "flavors." May be used in conjunction with **ICC color profiling**.

standards

Formal structures, procedures, and tools designed to promote uniformity and predictability. Typically developed, adopted, and promoted by large organizations that can advocate for their broad usage. Data standards enable the exchange of data, while technology standards enable the delivery of data between systems.

storage

The physical holding of **machine-readable** data. Data may be stored on a variety of media, including hard disk, magnetic tape, and optical media such as **CD-ROM**. All data and media should be stored under archival environmental conditions (for instance, with temperature, lighting, and humidity controls) as a basic **digital preservation** strategy. *See* **NAS**, **nearline**, **offline**, **online**, **redundant storage**, **SAN**, **storage networking**.

storage networking

Various methods of storing data **online** while optimizing **network** performance. Generally involves the separation of data **storage** from **server** processing, allowing data to be directly transferred between storage devices and **client** machines and avoiding server bottlenecks. An Open Storage Network (OSN) is a storage networking system that emphasizes the use of **standards** to promote flexibility, **interoperability**, and **scalability**. Storage networking vendors have cooperated to form the Open Storage Networking Initiative (OSNI), and the term is often used in marketing. *See* **NAS**, **SAN**.

submaster

See **derivative master.**

subpixel

Each red, green, and blue element in a **pixel** is referred to as a subpixel. Each carries a particular color **channel**.

TCP (Transmission Control Protocol)

The transport layer in the **TCP/IP standard** that provides reliable data delivery over the **Internet**. It divides files into numbered packets for sending and reassembles them in the correct order on delivery. It also detects corrupt or lost packets and resends them.

TCP/IP (Transmission Control Protocol/Internet Protocol)

The **ISO** standardized suite of **network** protocols that enables information systems to link to each other over the **Internet**, regardless of their computer platform. **TCP** and **IP** are software communication **standards** used to allow multiple computers to talk to each other in an error-free fashion.

technology preservation

A **digital preservation** strategy that involves preserving the complete technical environment, such as software, drivers, operating systems, fonts, passwords, and settings, necessary to facilitate access to archived data as well as its functionality, appearance, and behavior. An alternative approach is **emulation**.

TGM-I and TGM-II (Thesaurus for Graphic Materials I and II)

A body of terms maintained by the Library of Congress and used in subject **indexing** for pictorial materials such as prints, photographs, drawings, posters, architectural drawings, cartoons, and pictorial ephemera.

TGN (Getty Thesaurus of Geographic Names)

A **controlled vocabulary** maintained by the Getty Research Institute that lists and organizes alternative names for geographic locations.

thesaurus

A structured vocabulary of terms, typically including synonyms and/or hierarchical relationships, used to organize collections to allow cross-referencing for purposes of reference or retrieval. *See* **authority**, **controlled vocabulary**, **cataloguing**, **indexing**.

thumbnail

A proxy image, generally scaled to a much smaller size, used to represent a parent image in circumstances where loading the original is undesirable. Often used on the **Web** to display tables of smaller images with links to a larger view, preserving **bandwidth** and enabling the display of more images in the same area for the purposes of browsing.

TIFF (Tagged Image File Format)

A common image file **format**, TIFF is widely used as a format for storing uncompressed, or **losslessly compressed**, **digital image** data, though it also supports several **compression algorithms**. TIFF has gained wide acceptance for uses such as high-resolution scanning, image archiving, and editing applications.

transparency scanner

A **scanner** specifically designed to capture images from film or transparent media. *See* **drum scanner**, **digital camera**, **flatbed scanner**.

true-color image

Alternative term for 24-bit images.

ULAN (Union List of Artist Names)

A **controlled vocabulary** maintained by the Getty Research Institute that lists and organizes alternative names for artists.

vector graphic

An image composed of mathematically described elements, such as lines, arcs, and points (vectors), plotted in two- or three-dimensional space. The use of mathematical formulas to describe an image, instead of **pixels**, means vector graphics are not constrained by **resolution**, allowing them to be output at any size without loss of detail or other artifacts of pixel-based processing. Vector-based imaging is inappropriate for **continuous tone** imaging. *See* **bitmap**.

video card

The circuit board that enables a computer to display information on its screen. Determines the **resolution**, number of colors (**bit depth**), and **refresh rate** of display, in combination with the inherent limitations of the monitor used. Also known as a graphics adapter, display adapter, or video adapter.

VPN (Virtual Private Network)

A private data **network** that an organization can use to offer access to remote users or individuals, which makes use of public telecommunication infrastructure, such as the **Internet**, maintaining privacy through the use of a tunneling protocol and security procedures. Data is encrypted as it is sent and decrypted as it is received, so the virtual "tunnel" can only be traversed by properly encrypted data.

VRA Core Categories

A **metadata schema** specifically designed to describe not only original works but also their visual surrogates, including **digital images**, in considerable detail.

W3C (World Wide Web Consortium)

International consortium that develops vendor-neutral **open standards** and specifications for **Internet** and **Web**-based transactions, with the intent of promoting **interoperability**.

WAN (Wide Area Network)

A **network** that operates over a geographically dispersed area and is therefore typically slower than a **LAN**. WANs often link LANs together using a high-speed, long-distance connection.

watermark

A unique identifier added to a content file, such as an image, which can be visible or invisible to viewers. The mark, which could be a statement, symbol, or hidden encoding, is designed to persist through processing and serve as evidence of ownership in order to deter piracy.

wavelet compression

Compression technology, which may be lossy or lossless, that analyzes an image as a whole rather than dividing it into pixel blocks, as the **JPEG** compression **algorithm** does. This allows greater compression while still maintaining acceptable image quality. Wavelet technology can achieve compression ratios for color images of 20:1 to 300:1, and of 10:1 to 50:1 for **gray scale** images. *See* **JPEG2000**.

Web

See **World Wide Web**.

Web browser

A **client** program installed on a user's computer that makes requests of a **World Wide Web server** using the Hypertext Transfer Protocol (**HTTP**). The most common Web browser programs currently in use are Netscape Navigator and Microsoft Internet Explorer.

Wintel

Personal computers that run one of the Windows operating systems produced by Microsoft and an Intel microprocessor, such as the Pentium Pro. Also known as PCs. Generally contrasted with systems that use another operating system, especially Apple personal computers that use a Macintosh operating system and Motorola or PowerPC microprocessors.

World Wide Web

A vast, distributed **client/server** architecture for retrieving hypermedia or hypertext (interactive documents and media joined together by "links" or selectable connections) over the **Internet** using the Hypertext Transfer Protocol **(HTTP)**.

wrapper

A file used to encapsulate another file or collection of files. For example, the **METS** system either "contains" a **digital** file and its metadata in an **XML** file that describes them or points to files stored elsewhere.

XHTML (eXtensible HyperText Markup Language)

A reformulation of **HTML** as an application of **XML** designed to express **Web** pages. Users can extend XHTML to include new elements and attributes, and XHTML documents can be read and validated with standard XML tools.

XML (eXtensible Markup Language)

A simplified subset of **SGML** designed for use with the **World Wide Web** that provides for more sophisticated, meaningful (semantic), and flexible data structuring and validation than **HTML**. XML is widely forecast to be the successor to HTML as the language of the **Web** and is an essential component of the proposed **Semantic Web**. *See* **XHTML, XSD, XSL, XSLT**.

XML-enabled

Designed to be compatible with **XML**. For instance, XML-enabled **databases** use **middleware** to translate between **XML** documents and traditional relational or object-relational **databases**. *See* **native-XML**.

XSD (XML Schema Definition)

A specification designed to express relational or non-narrative data in **XML**. Provides a standard way to validate data sets and to exchange them between applications. *See* **database**, **DTD**.

XSL (eXtensible Stylesheet Language)

The language used to create style sheets that describe how **XML**-structured data is to be displayed to **Web** users.

XSLT (eXtensible Stylesheet Language Transformations)

May be regarded as an extension of **XSL**. Provides a standard way to reorganize the data represented in one **XML** document into a new XML document with a different structure, or into another format altogether.

Z39.50

ISO 23950 and **ANSI/NISO** Z39.50 standard information retrieval protocol, a **client/server**-based method of searching and retrieving information from heterogeneous (usually remote) **databases**, most often used in bibliographic implementations. The ZNG (Z39.50 Next Generation) Initiative aims to update Z39.50 and make it compatible with **XML** and other current **Web** technologies.

The following sources were referred to in creating this glossary: Andy Moore's *The Imaging Glossary, Electronic Document and Image Processing Terms, Acronyms and Concepts* (1991); *The Electronic Imaging Glossary* (1994), compiled by Mimi King for the Library and Information Technology Association of the American Library Association; Internet.com's Webopedia; the FOLDOC Free On-Line Dictionary of Computing; and TechTarget's IT-specific encyclopedia Whatis?com. Maria Bonn, Nigel Kerr, and Jim Schlemmer contributed to the development of further definitions used in the first edition.

Online Resources

Organizations

The following groups offer a wealth of resources on all aspects of digitizing cultural heritage collections.

AHDS: Arts and Humanities Data Service, <www.ahds.ac.uk>

CDL: California Digital Library, <www.cdlib.org>

CDP: Colorado Digitization Program, <www.cdpheritage.org>

CEDARS: Curl Exemplars in Digital ARchiveS, <www.leeds.ac.uk/cedars>

CHIN: Canadian Heritage Information Network, <www.chin.gc.ca>

CIDOC: International Committee for Documentation (a committee of ICOM), <icom.museum/internationals.html#cidoc>

CIMI: Consortium for the Interchange of Museum Information, <www.cimi.org>

CLIR: Council on Library and Information Resources, <www.clir.org>

CNI: Coalition for Networked Information, <www.cni.org>

DIMTI: Digital Imaging & Media Technology Initiative, <images.library.uiuc.edu>

DLF: Digital Library Federation, <www.diglib.org>

ECHO: North Carolina Exploring Cultural Heritage Online, <www.ncecho.org>

HEDS: Higher Education Digitisation Service, <heds.herts.ac.uk>

ICOM: International Council of Museums, <icom.museum>

IFLA: International Federation of Library Associations and Institutions, <www.ifla.org>

InterPARES: International Research on Permanent Authentic Records in Electronic Systems, <www.interpares.org>

MCN: Museum Computer Network, <www.mcn.edu>

mda: formerly the Museum Documentation Association, <www.mda.org.uk>

NDLP: National Digital Library Program/American Memory, <lcweb2.loc.gov/ammem>

NZDL: New Zealand Digital Library Project, <www.nzdl.org>

OCLC: Online Computer Library Center, Inc., <www.oclc.org>

PADI: Preserving Access to Digital Information, <www.nla.gov.au/padi/>

SunSITE: Berkeley Digital Library Sun Software, Information and Technology Exchange, <sunsite.berkeley.edu>, Information Longevity <sunsite.berkeley.edu/Longevity>

TASI: Technical Advisory Service for Images, <www.tasi.ac.uk>

UKOLN: UK Office for Library and Information Networking, <www.ukoln.ac.uk>

VADS: Visual Arts Data Service, <vads.ahds.ac.uk>

VRA: Visual Resources Association, <www.vraweb.org>

WAI: Web Accessibility Initiative, <www.w3.org/WAI>

Journals, Magazines, and Newsletters

Ariadne, <www.ariadne.ac.uk>

D-Lib Magazine, <www.dlib.org>

eCulture, <www.cordis.lu/ist/ka3/digicult/newsletter.htm>

First Monday, <www.firstmonday.dk>

RLG DigiNews, <www.rlg.org/preserv/diginews/>

[All URLs accessed January 10, 2003.]

Bibliography

Arms, William Y. *Digital Libraries*. Cambridge: MIT Press, 2000.

Baca, Murtha, ed. *Introduction to Metadata: Pathways to Digital Information*. Los Angeles: Getty Research Institute, 1998. Available on the World Wide Web at <www.getty.edu/research/ institute/ standards/>.

———, ed. *Introduction to Art Image Access: Issues, Tools, Standards, Strategies*. Los Angeles: Getty Research Institute, 2002. Available on the World Wide Web at <www.getty.edu/research/ institute/standards/>.

Besser, Howard, Rosalie Lack, and Robert Yamashita, eds. *Cost and Use of Digital Images on University Campuses: Lessons from the Museum Educational Site Licensing Project*, special issue of *Visual Resources: An International Journal of Documentation* 14 (4), 1999: 355–503.

Borgman, Christine L. *From Gutenberg to the Global Information Infrastructure: Access to Information in the Networked World* (Digital Libraries and Electronic Publishing). Cambridge: MIT Press, 2000.

Committee on Intellectual Property Rights and Emerging Information Infrastructure. *The Digital Dilemma: Intellectual Property in the Information Age*. Washington, DC: National Academy Press, 2000.

Coppock, Terry, ed. *Making Information Available in Digital Format: Perspectives from Practitioners*. London: The Stationery Office Books, 1999.

Deegan, Marilyn, and Simon Tanner. *Digital Futures: Strategies for the Information Age*. New York: Neal-Schuman, 2002.

Grout, Catherine, Phill Purdy, Janine Ryder, et al. *Creating Digital Resources for the Visual Arts: Standards and Good Practice* (The Arts and Humanities Data Service Guides to Good Practice). Oxford, UK: Oxbow Books, 2000.

Harris, Lesley Ellen. *Licensing Digital Content: A Practical Guide for Librarians*. Chicago: Library Association Editions, 2002.

Hunter, Gregory S. *Preserving Digital Information: A How-To-Do-It Manual* (How-To-Do-It Manual for Librarians, No. 93). New York: Neal-Schuman, 2000.

Jones, Maggie, and Neil Beagrie. *Preservation Management of Digital Materials: A Handbook*. London: British Library Publications, 2002.

Kenney, Anne R., and Oya Y. Rieger, eds. *Moving Theory into Practice: Digital Imaging for Libraries and Archives*. Mountain View, CA: Research Libraries Group, 2000.

Lanzi, Elisa, ed. *Introduction to Vocabularies: Enhancing Access to Cultural Heritage Information*. Los Angeles: Getty Research Institute, 1998. Available on the World Wide Web at <www.getty.edu/ research/institute/vocabulary/>.

Lazinger, Susan S. *Digital Preservation and Metadata: History, Theory, Practice*. Englewood, CO: Libraries Unlimited, 2001.

Lee, Stuart D. *Digital Imaging: A Practical Handbook*. New York: Neal-Schuman, 2001.

Lee, Sul H., ed. *Impact of Digital Technology on Library Collections and Resource Sharing*. Binghamton, NY: Haworth Press, 2003.

Sitts, Maxine K., ed. *Handbook for Digital Projects: A Management Tool for Preservation and Access*. Andover, MA: Northeast Document Conservation Center, 2000. Available on the World Wide Web at <www.nedcc.org/digital>.

Stephenson, Christie, and Patricia McClung, eds. *Delivering Digital Images: Cultural Heritage Resources for Education* (Museum Educational Site Licensing Project). Los Angeles: Getty Research Institute, 1998.

———. *Images Online: Perspectives on the Museum Educational Site Licensing Project*. Los Angeles: Getty Research Institute, 1998.

[All URLs accessed January 10, 2003.]

Contributors

Howard Besser
(howard.besser@nyu.edu) is the founding director of New York University's master's degree program in Moving Image Preservation. He was formerly a professor in the School of Education and Information Studies at the University of California, Los Angeles, and has in the past been in charge of information technology for two art museums. Since 1985, he has also been involved in numerous projects dealing with the digitization of cultural heritage materials and has been in the forefront of the investigation of issues of digital longevity. His teaching and research interests include multimedia, image databases, digital libraries, metadata standards, intellectual property, digital longevity, information literacy, and the social and cultural impact of new information technologies. He is the author of several dozen articles and book chapters on these subjects. He is a participant in the InterPARES (International Research on Permanent Authentic Records in Electronic Systems) 2 project and has served on various national and international committees and panels on issues surrounding the documentation and archiving of digital information.

Sally Hubbard (shubbard@getty.edu) is digital projects manager at the Getty Research Institute, with responsibility for the digitization, persistence, and continued accessibility of virtual collections. She was formerly new media coordinator of the Film and Television Archive at the University of California, Los Angeles, where she developed educational multimedia resources. She served as associate editor for *The Moving Image*, the journal of the Association of Moving Image Archivists; is a participant in the InterPARES 2 project and the Education and Outreach Committee of the Moving Image Collection (MIC) portal; and has presented numerous papers and workshops on digital preservation and related issues. She has a master's degree in African Area Studies from UCLA.

Deborah Lenert (dlenert@getty.edu) is digital projects specialist at the Getty Research Institute. She is involved in digitization and collection information projects, primarily dealing with text-and-image-based special collections materials. She has previously worked in software and database development and user training in the area of records management. She has a master's degree in Instruction from Drexel University.

Illustration Credits

Other titles in the *Introduction To* series

Introduction to Archival Organization and Description
Michael J. Fox and Peter L. Wilkerson
Edited by Suzanne R. Warren
66 pages
1 b/w illustration

Introduction to Art Image Access
Issues, Tools, Standards, Strategies
Edited by Murtha Baca
104 pages
8 color and 21 b/w illustrations

Introduction to Managing Digital Assets
Options for Cultural and Educational Organizations
Diane M. Zorich
167 pages
1 b/w illustration

Introduction to Metadata
Pathways to Digital Information
Edited by Murtha Baca
47 pages
1 b/w illustration

Introducción a los metadatos
Vías a la información digital
Spanish-language edition of *Introduction to Metadata*
Edited by Murtha Baca
47 pages
1 b/w illustration

Introduction to Object ID
Guidelines for Making Records that Describe Art, Antiques, and Antiquities
Robin Thornes with Peter Dorrell and Henry Lie
72 pages
31 b/w illustrations

Introduction to Vocabularies
Enhancing Access to Cultural Heritage Information
Elisa Lanzi
70 pages
5 b/w illustrations